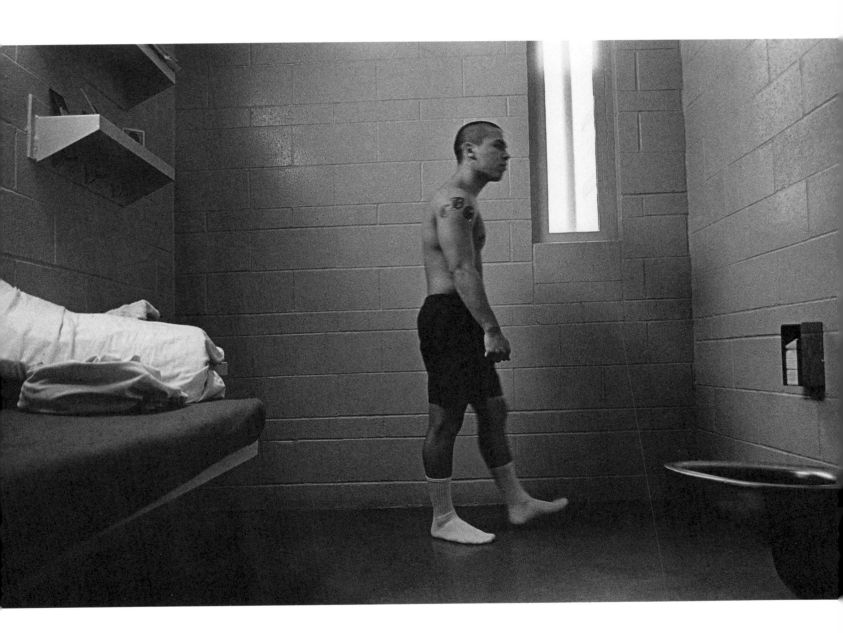

JUVENILE

JOSEPH RODRÍGUEZ

pH POWERHOUSE BOOKS NEW YORK, NY

One writes out of one thing only—one's own experience. Everything depends on how relentlessly one forces from this experience the last drop, sweet or bitter, it can possibly give. This is the only real concern of the artist, to recreate out of the disorder of life that order which is art. The difficulty, for me, of being a Negro writer was the fact that I was, in effect, prohibited from examining my own experience too closely by the tremendous demands and the very real dangers of my social situation.

—James Baldwin, "Autobiographical Notes," *Collected Essays*

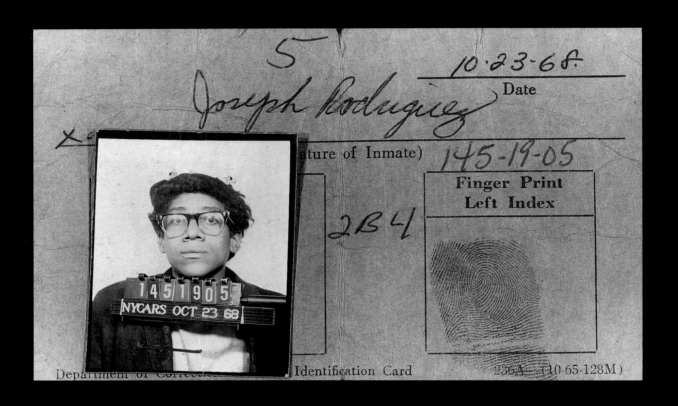

Joseph Rodríguez's inmate identification card from Rikers Island

Recently, I have been going back in time.

Just before the new millennium my mother called me to tell me that, while going through boxes of old papers, she'd found some letters I had written to her when I was incarcerated at Rikers Island. They were the usual prison letters: "I know that I messed up, and I am sorry I hurt you and the family, and when I get out I am going to make things better."

That was in the 1970s, and the psychedelic era was in full swing, with all its love, peace, and drugs among us flower children and radicals. I ran away from home at sixteen and became a hippie—I considered myself very anti-establishment. I started sleeping in Brooklyn's Prospect Park. There was a sense of adventure and camaraderie with my group of teens back then. Among them, I felt accepted for who I was.

Drugs were everywhere. It was the usual stuff, starting with weed and then eventually graduating to heroin...and later to methadone. I soon became a slave to the "white lady." I became a dealer and a thief to support my habit. One night I was caught breaking into a store. The cops caught me red-handed, with one foot inside the air-conditioner duct and one foot outside. "Shit, not again!" I said to myself as I was hauled away in cuffs to night court.

Kicking the habit was cold turkey in those days: they didn't give you anything for the nightmarish pain, they just let you throw up and shit in your pants. So I just had to put my hands up and deal with my own turmoil. One day, coming back to my cell from the mess hall after breakfast, I considered jumping off the third tier, but I didn't have the nerve. "You're such a *punk*!" I remember saying to myself.

Although it was a hellhole, Rikers Island forced me to think. As I tried to deal with my problems there, I realized that prison life was not for me—although it wasn't the last time I'd be inside.

When I finally got out, I was still considered a juvenile offender, and was put on probation. I decided to get on a methadone program. I had tried many other programs, but

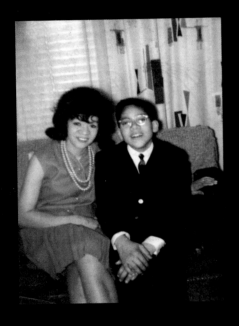

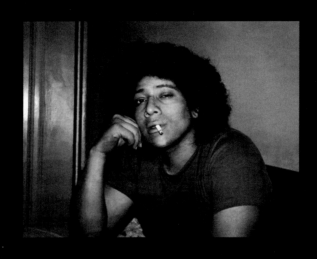

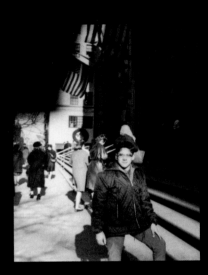

LEFT TO RIGHT: Joseph Rodríguez in Brooklyn, 1961; Rodríguez in 1971; Rodríguez in front of New York's Saint Patrick's Cathedral, 1963

they didn't work for me. I remember telling my mother that I was on a recovery program, and s said: "Don't lie to me! Look at you—you're high on that shit again!" The doctors had started out at 90mg of methadone, which, until I got used to the dosage, just made me nod out and lc like I was sucking on my toes.

I was hurt at first by what my mother said, but I knew it was going to take a lot convincing for her to trust me. It didn't help my case that my stepfather was also a drug add and my mom had had her fill of his shit. His usual routine was this: after he got out of pris he would stay clean for a couple of weeks, and then he was right back to shooting up aga I remember coming home from school when I was ten, and seeing him nodding, with the nee sticking out of his skin as the blood ran down his arm.

My mother married my stepfather when I was ten. At first he was nice. He and mother had two beautiful children of their own. Later on, when she found out he was doing h drugs, she was overwhelmed. In those days, the early 1960s, you didn't talk about this s openly, so she carried the weight of it—she was a very strong woman. He stopped going to job as a bricklayer, and soon the collection agencies started coming to the house. My stepfat took everything that mattered to me: my Lionel trains, my first transistor radio—all of which real father had bought me. I hated him, and I hated myself for being stuck in this situation.

After I got adjusted to my new drug habit (methadone—much worse than any herc I knew that I wanted to do something with my life. I guess I had always had that desire, but di know how to get there. I'd thought that I could get away with stuff, but I learned that there always consequences: getting busted, overdosing, doing time.

I slowly started to learn how to redeem myself by looking deep inside. I learned that th is a balance, a yin and yang of life.

With my photography, I have learned how to deal with these experiences.

—Joseph Rodríguez, August 2

1414 HAZEN STREET
EAST ELMHURST, N. Y. 11370

Block #5 (CELL NO 3A1)

From RODRIGUEZ, Joseph No. 1451905

To CARMEN RODRIGUEZ Relation-Ship MOTHER

Address 807-8TH AVE APT 4 REAR

City BROOKLYN State N.Y. 11215

DATE 11/2/68

DEAR MOM,

HI THERE! I WISH I WAS HOME WITH YOU AND MARK AND SONJA, I WAITED FOR THE BAIL BUT I SEE IT DID NOT WORK OUT. I PROMISE YOU THAT WHEN I GET OUT OF HERE THAT I WILL JOIN THE NAVY OR GO BACK TO SCHOOL BECAUSE I KNOW I PUT YOU THREW A LOT OF HARDSHIPS & TROUBLES, AND I AM GOING TO STRAIGHTEN UP AND ONE DAY YOU ARE GOING TO BE PROUD OF ME BECAUSE I DON'T WANT MARK OR SONJA MAKING THE SAME MISTAKES I HAVE MADE. I WANT TO GO IN THE NAVY AND TRY TO FINISH MY SCHOOLING BECAUSE I STILL LIKE PRINTING SO MUCH THAT I TRIED TO GET IN THE SCHOOL FOR PRINTING IN HERE. ONE OF THESE DAYS I INTEND TO BE WHAT I WANT EVEN IF I HAVE TO CRAWL FOR IT AND START FROM THE BOTTOM, BECAUSE I WANT TO HELP YOU OUT AND MAYBE ONE DAY MAKE IT ON MY OWN, AND MOM LET ME TELL YOU SOMETHING DURING THIS PAST SUMMER SOME PEOPLE THAT I DON'T LOVE YOU AND THE KIDS BECAUSE BOY! I LOVE YOU AND THE KIDS WITH ALL MY HEART AND RIGHT NOW I AM CRYING BECAUSE OF WHAT I HAVE DONE TO YOU & KIDS YOU CAN EVEN SEE THE TEAR DROPS ON THIS LETTER I ALWAYS THOUGHT YOU NEVER UNDERSTOOD ME BECAUSE SOME OF THE THINGS THAT I DO YOU THINK ARE TERRIBLE BUT THEY AREN'T BUT OTHERS ARE DANGEROUS AND I APPRECIATE WHEN

DO NOT SEND CASH

Misc. 450M-426196(68) 346

YOU TELL ME WHAT THEY CAN DO TO YOU. AND IF I GET OUT
OF HERE WE ARE GOING TO TRY TO UNDERSTAND EACH OTHER,
SO I WONT HAVE ANY PROBLEMS. I GOT THE MONEY YOU
SEND ME AND I BOUGHT A CARTON CIGARETTES AND COOKIES
+ CANDY BUT I HAD TO PAY BACK A COUPLE OF PACKS OF
CIGARETTES, JUST IN CASE I AM IN HERE FOR ANOTHER
COUPLES OF WEEKS OR MONTHS. MONDAY WHEN I GO TO COURT
TRY AND GIVE ME ABOUT $3.00 FOR SOAP, DEODORANT, ETC,
GETTING BACK TO THE BAIL. I WAS TOLD BY THE PATROLMAN
THAT IF YOU HAVE AN LIFE INSURANCE POLICY AND IF IT IS
ALMOST PAID UP YOU CAN BRING IT TO THE BAIL'S BONDSMEN
AND HE MIGHT ACCEPT IT. PLEASE TRY IT BECAUSE I CANT
TAKE IT IN HERE ANY LONGER. I HOPE TO SEE YOU AT COURT

WITH ALL MY LOVE

CHICKIE

P.S. I HOPE THE KIDS AND YOU ARE ALLRIGHT
GIVE THEM ALL MY LOVE

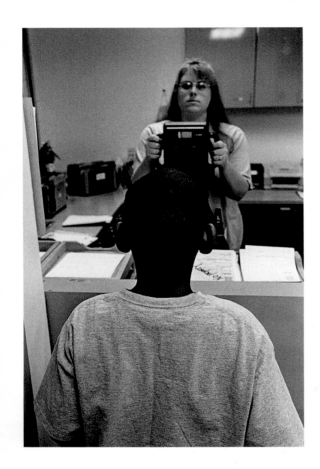

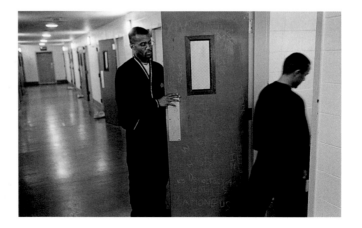

ALL PHOTOGRAPHS IN THE *JUVENILE* PROJECT WERE MADE IN 1999–2000.
Unless otherwise indicated, the institutional setting throughout is the Santa Clara County Juvenile Hall, San Jose, California.

INTRODUCTION

NELL BERNSTEIN

Several years ago, I found myself driving a sixteen-year-old friend, at her request, to place herself behind bars.

The twenty-mile journey took us several hours. We stopped at a bookstore and she picked out a stack of novels—Toni Morrison, Gloria Naylor, Jamaica Kincaid—which I was going to bring in to her one at a time: you are not allowed to carry anything with you when you enter juvenile hall. At a nearby mall, she chose a lunch of ice cream and candy, a child's last meal.

"Slow down," she kept saying as we crawled along the freeway. By the time we reached the exit, we were pressing the forty mph minimum, and I could feel how much it was costing her to submit voluntarily to a system that perceived her as a menace.

I was editing a youth newspaper called *YO! (Youth Outlook)* at Pacific News Service in San Francisco when I met Sayyadina in 1995. A foster-care fugitive who'd been through more than twenty "placements" by the age of fourteen, she'd decided she was better off on her own and had walked out of her group home to live on friends' couches and on the street. Enrolling herself in high school and lying about her age to get waitressing jobs, she'd managed to go undetected by child-welfare workers for two years.

Then her mother, who had abandoned her as a child, came back to town with a new boyfriend. One night Sayyadina and the boyfriend argued, and he tried to beat her with a belt. She fought back, and threw a television through the window. Her mother called the police and Sayyadina was carted off to juvenile hall for a few weeks, then assigned to another group home. There she got into a fight with another girl. Sayyadina ran. The group home reported the altercation and Sayyadina's subsequent flight to her probation officer, who issued a warrant for her arrest.

By that time, Sayyadina had been working as a writer at *Youth Outlook* for nearly two years, and our office was the first place she sought refuge. She showed up the following morning and asked me to call her probation officer to help negotiate her return.

"I've discharged her from the program," the officer told me, her voice a door slamming shut. "She needs to turn herself in."

"Needs to" is a figure of speech that is popular with juvenile authorities, used to describe actions that they themselves are determined to compel. Sayyadina had no choice but to turn herself in; on her real list of needs—which ranged from love and attention to a high-school education and a jacket to keep her warm—going to jail was pretty low. But until she met that "need," we were told, she could forget about the rest.

And so she complied, asking me to deliver her to juvenile hall, where she was stripped of her clothes and her belongings, issued slippers and a thin cotton jumpsuit, and ushered out of sight.

The probation officer had told me that Sayyadina would be in kept in juvenile hall until a new placement was found for her. New to the process, I figured that

would take a couple of weeks. As it turned out, Sayyadina was kept behind bars for nearly six months, the legal limit for someone who has not been sentenced for a crime, someone who is simply waiting for a place to go.

As far as I could tell—and I tried my best to find out—very little effort was made during that time to find somewhere other than a cell for Sayyadina to lay her head. I tried looking for an alternative, but found myself nearly frozen out by the system. I couldn't get a phone call returned by the probation officer, and had to grovel and plead for permission even to visit, since my role corresponded to none of the categories on the visitor's pass: parent, guardian, or custodian.

The facilities where young people are confined in the United States operate under a variety of euphemistic names that are as soothing as they are implausible: "guidance center," "training school," "boys' ranch," "camp." New arrivals test the door and know exactly where they are. Each Saturday for six months when I went to spend time with Sayyadina, I passed through a metal detector, relinquished my keys and wallet, and entered a sealed building. "This institution uses pepper spray," warned signs along the corridors.

My friend's greeting was always the same: "Who asked about me?" I brought messages and books, and learned to play dominoes. Sometimes, when she was feeling particularly desperate, we would decorate the apartment she hoped one day to have, stock the refrigerator, constructing a home for her out of words and images.

After a couple of months, Sayyadina was expelled from the juvenile hall's in-house school for challenging the teacher and riling up her fellow students. So she sat in her cell and read. "I lived in my books," she says now, "until I could get away. I read about heroines who were kept in towers. I read about women who survived obstacles, and reading about survivors made me feel like one. If they could leave slavery and defy Rome, so could I."

In 1989, juvenile courts handled 1.2 million delinquency cases. By 1998, this number had risen 44 percent, to 1.8 million. Over roughly this same period, the violent-crime index—which measures arrest rates for violent crime relative to population—dropped for juveniles. Today, there are more than a hundred thousand young people behind bars in the United States, fourteen thousand of them in adult jails or prisons. Two-thirds of them are young people of color, though minority youth represents just one-third of the juvenile population. Most of them are boys, but there are increasing numbers of girls: in the decade between 1989 and 1998, the number of girls behind bars rose by 56 percent, compared to a 20 percent increase among boys. Each year, about eleven thousand detainees will try to kill themselves.

Inside the girls' unit where I visited Sayyadina, I got to know some of the other "wards," their parents, their grandmothers, and their children. Like Sayyadina—and like the great majority of juvenile offenders—most were not there for committing violent crimes. Most had been the victims of violence themselves: abused by parents, raped by boyfriends, assaulted on the street.

On my first visit, inside the receiving unit where new detainees are processed, I watched a skinny pre-adolescent boy rest his arm on his mother's knee as she told him in elaborate detail about the family dinner he had missed the evening before. When they had brought him into juvenile hall the previous night, it had taken three guards to restrain him.

Later, I watched three generations in the girls' unit struggle with the impact of incarceration. A little girl in overalls scampered across the scuffed linoleum floor. From time to time she cast shy glances at her mother, a teenager who slouched in a plastic chair playing gin rummy with her own mother, a tired-looking woman in her forties. A guard with a ring of keys at his belt joked to the little girl that he'd lock her up if she didn't settle down, and she ran back to huddle beside her grandmother.

Inside juvenile hall, young people do what they can to find solace. Some write letters to anyone they can think of, asking for forgiveness, complaining about the food, begging for a reply and money for stamps. Some slash at their wrists and arms with contraband paper clips or ballpoint pens, hoping for a glimpse of their own blood.

Katrina, who was arrested for auto theft after taking a friend's car without permission,

lifted weights in an effort, as she explained, to "get all my anger out." "I like to feel the pain because I've been through it all and I'm used to it," she told me. "It don't scare me. You know how some people get a rush out of doing drugs? I get a rush out of feeling pain."

Kethan wrote poems:

dreaming while closing my eyes,
feeling heat from the core of my heart,
sometimes feeling apart like a lost destiny,
Don't question me!

After six months behind bars, Sayyadina was shipped off to another group home. When the staff there told her she'd have to quit her early-morning job at a bagel store—the one she'd taken in order to save money for college—because it "interfered with the program," she ran again. Because she was a minor who had turned her back on her only legal guardian—the state— it was illegal for her to work, to go to school, to take care of herself. But she did these things anyway, staying with an assortment of friends and working as everything from a receptionist to a telephone psychic, and she managed to avoid getting noticed by the system until she turned eighteen, when legal adulthood liberated her from its scrutiny.

At one point, while Sayyadina was still inside, I had a look at her file. A juvenile-hall psychiatrist had evaluated her and had found her hostile and manipulative (she'd told him she knew he was reporting back to probation and therefore did not intend to reveal anything that might reflect badly on her). When she complained that meetings about her fate were being held "behind my back," declaring that it was her life and she had a right to be included, she earned a diagnosis of paranoia.

The young woman I knew was industrious, eloquent, and doing her best against terrific odds. The girl in the file folder—angry, evasive, lacking in promise, and difficult to handle—was a stranger to me. What face had she shown them? Whom did they think they knew?

When Sayyadina turned up, years later, in Joseph Rodríguez's photographs of juvenile offenders and ex-offenders, I knew her right away.

I saw her sorrow and her courage; the part of her that remained caged and the part that never would be; a young woman who had left slavery, defied Rome, and was making her way home.

The American juvenile court was invented in Illinois in 1899, with the mission of rescuing, rather than punishing, America's wayward youth. Under the doctrine of *parens patriae*, or "the state as parent," juvenile-court judges had wide latitude to address everything from robbery and assault to truancy and playing ball in the street. One judge, speaking a hundred years ago before the National Prison Association, explained that he "endeavored to act in each case as I would were it my own son who was before me in the library at home, charged with some misconduct."

Because of the court's presumed benevolence, arrested juveniles didn't get many of the standard elements of due process. Over the following decades, a series of Supreme Court decisions extended some protections—including the right to counsel and the right to confront witnesses—to juveniles. But others, like the right to a trial by jury, remain left out.

A century after the juvenile court's inception, the goal of "child saving" has given way to a powerful movement to recriminalize juvenile wrongdoing—to return the court's focus to a child's bad acts rather than to his tender years. During the 1990s, the great majority of states made increasing numbers of juveniles eligible for trial in adult criminal court. Even as current law pro-hibits runaway teens like Sayyadina from living freely as adults, it deems children her age and younger "criminally sophisticated" and punishes them as adults.

Today, all fifty states have provisions for trying juveniles as adults for a variety of crimes— including not only acts of violence but also drug, property, and public-order offenses—and upon conviction sending them to adult prisons, where they are much more likely to be raped and abused than in juvenile facilities, and from which they are much more likely to return to crime, later to be rearrested. In 2000, voters in California— which already had one of the highest youth-incarceration rates in the nation—approved Proposition 21, the Gang Violence and Juvenile

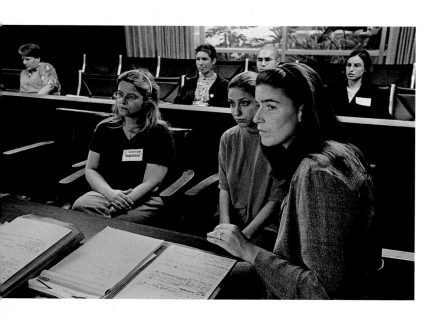

ABOVE:
*Public-
defender
Christa
Cannon,
at drug-
treatment
court with a
young client
and the
girl's
mother*

RIGHT:
*Christa
consoling
Katrina,
who has
been
removed
from a
group home*

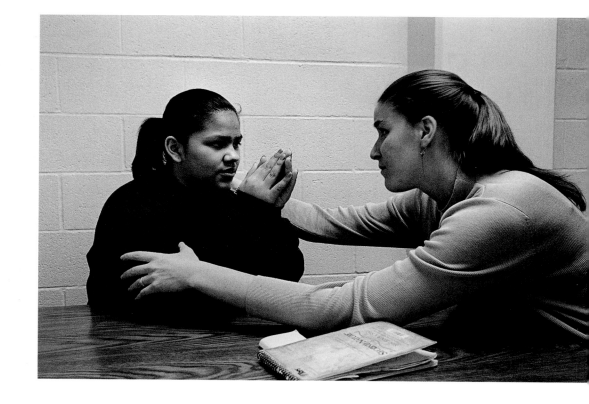

juvenile hall. "You can't, because you broke the law. Only criminals are here. Can't you see? Take a look around."

Rather than rehabilitating, says Mousie, juvenile hall "makes you worse, because you start believing what they're telling you. Once you get put in the system, you consider yourself a criminal. So when you get out, you think: 'Oh well, I've been through it before. Why not again?' I started believing I wasn't gonna be nobody."

Not long after Proposition 21 became law, I assisted in a writing workshop inside juvenile hall. Lance, the workshop leader, was a twenty-one-year-old ex-offender. This unit held young men and women, and before Lance could begin that day, he had to calm a conflict over something someone had said about someone else's man. After a few moments, he had deflected the fight and the group had begun to focus on the questions he wanted them to write about during the forty-five-minute session.

If Proposition 21 had passed a few years earlier, these young people would likely never have met Lance, and I probably wouldn't have either. He'd have been locked up for decades, not to emerge until he was middle-aged.

When Lance was thirteen, already a veteran of group homes and residential treatment centers, he moved to San Francisco's Fillmore district. He was the only white kid in a mostly black neighborhood. He was fat. He had a lot to prove. He started out smoking weed and shoplifting. Then one of the "big dogs" in the neighborhood took him on, and Lance moved on to selling crack and robbing other drug dealers. He slimmed down. A friend taught him how to fight.

The first time Lance went to juvenile hall, he had stolen a leather jacket. He was released the following morning. The second time, he had assaulted the owner of a corner store. He spent a weekend behind bars, and then was released on probation.

His third and final arrest was for a crime which so troubles him that he is not willing to talk about it publicly. He was charged with seven felony counts, including kidnapping, armed robbery, and false imprisonment. At the time, the minimum age to be tried as an adult in California was sixteen. Lance was fifteen. A seventeen-year-old friend of his who was charged with the same crime is serving twenty years. Lance was tried and convicted as a juvenile and released after four years, when he was nineteen.

In juvenile hall, a youth worker started Lance reading novels, prison autobiographies, and books about religion. He began writing, mailing his poems and narratives to *The Beat Within*, Pacific News Service's magazine for incarcerated youth. When he got out, he showed up at the office in San Francisco and was given a job leading workshops.

When the city became too much for him—one friend was shot, another stabbed—Lance moved to the country, where his mother lived, and found work as a stonemason. He soon fell in love with a "beautiful, excellent, great, intelligent" woman. A boot camp for juvenile offenders opened up nearby and Lance was hired as a counselor. The kids call him "Coach."

Too few of Lance or Sayyadina's former hallmates will fare as well as these two have. Only 11.5 percent of those in California Youth Authority facilities—which house the state's most serious underage offenders—can pass the California High School Exit Exam. More than 65 percent are substance abusers. More than half have mental-health problems. Of the two thousand young offenders released each year from California Youth Authority facilities, more than 90 percent will be arrested again.

"I feel for these kids," says Joe. "I can predict their future outcomes, and that's painful. You follow up in a couple years, and they're in the same situation, only now they've got kids. That's what makes me most angry in this country—how we'll let this process continue generation after generation. It's very difficult to interview people and have them say: 'My father, my uncle, my grand-father were in prison. Now I'm going to prison.'"

Sayyadina called this morning, as she does every couple of months, to tell me how she's doing and to ask about my kids. She's twenty-one now, and bursting with news.

She's enrolled herself at a community college and signed up for courses in communications and music. Eventually, she hopes to transfer to

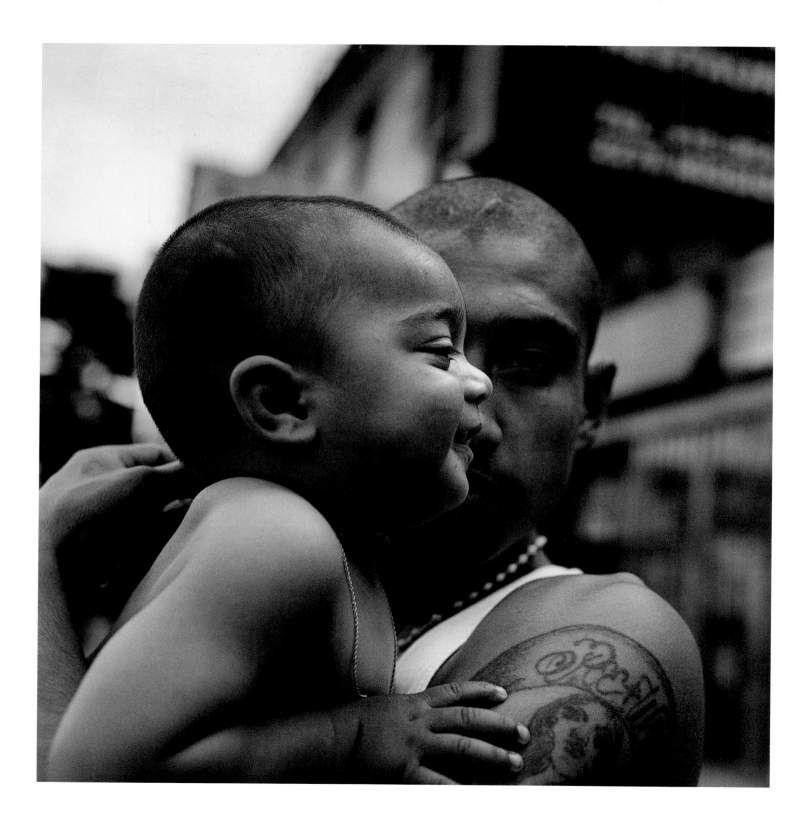

Juilliard, because she heard that Samuel L. Jackson and Robert DeNiro went there. She now performs as a rapper and a poet at local clubs, and was just promoted from cashier to waitress at an upscale hamburger place. On a good night, she brings home a hundred dollars. She's renting a room in a friend's apartment while she saves up to buy a sailboat, on which she intends to live. "I'm looking for a harbor," she says, and it takes me a moment to understand that she means it literally.

"My distrust for authority saved me," she says of her time behind bars. "Whether I was in jail or not, I was always free because I never thought I belonged there. I never let anyone convince me I did."

If someone asked me what exactly had "saved" Sayyadina, or Lance, or any of the other young offenders I have met who have defied expectations and grown into their better selves, I'd pick a different term to express the same idea. I'd say it was imagination: the capacity to envision a future for themselves other than the one the system prescribed.

But for every Lance, and for every Sayyadina, dozens of kids enter juvenile hall and never make it out again. They give up—they come to believe in and *live* the labels placed on them. A system intended originally to protect and reform becomes instead a portal to more serious delinquency, and then to adult criminality.

Lance told me that working as a counselor with young offenders helped him. He says:

[I can] see why juvenile justice is such a difficult topic. I can see why everyone's struggling with it. I struggle with it, and I lived it. Some of these young people that are getting locked up are there for double homicides. They're in there and they're gang bangers to the heart. And if they did get out, they might just go out and kill a couple more people. But then there are those people that...the guidance wasn't there, the self-esteem wasn't there, and their environment played such a role in them not making it in this world.

There are always gonna be people that need to go away, that are just gonna be ruining the lives of others if they're free. I know the attitude, and it's a nasty, deadly attitude. They should still serve harsh sentences, but they should serve them in places that

they can learn from, and be monitored, and see if they really are capable of change.

I believe in the human soul, the spirit, because it's such a powerful, unlimited thing. And I believe that young people need exposure to wisdom and knowledge and truth. They need to be molded and shaped and exposed to beautiful things and new aspects of life and different possibilities. They need to be given that chance before they're thrown away by society.

"You've met me *once*," Sayyadina screamed at her probation officer over the phone. "You don't know what I need!"

Neither do I. But I do know that we owe her. We owe all of them. We've taken their freedom, their right to self-determination, and now our obligation to them is tremendous. It is, for the sum of us, the same as a parent's, because we are claiming the rights of a parent. For the authority we claim, we owe care in equal measure. That's the tacit deal between parent and child, but we make no such promise to those toward whom we presume to act *in loco parentis*. "If you needed attention," a counselor told Sayyadina in juvenile hall, "you shouldn't have gotten yourself locked up."

Joseph Rodríguez has paid close and respectful attention to a group of young people we'd prefer to consign to invisibility while they sit in our juvenile prisons—and to irrelevance once they emerge. His is no human-rights exposé; the conditions of confinement are of only secondary interest to him. What fuels his photographs of young people behind bars and on the street is his ability to look *with* them as well as at them and to see what they are seeking as well as where they are.

It's an angle of approach that makes visible the prospect of redemption, not only for the children we incarcerate, but also for the system that contains them.

AUGUST 2003

PeeWee and his son in San Francisco's Mission district

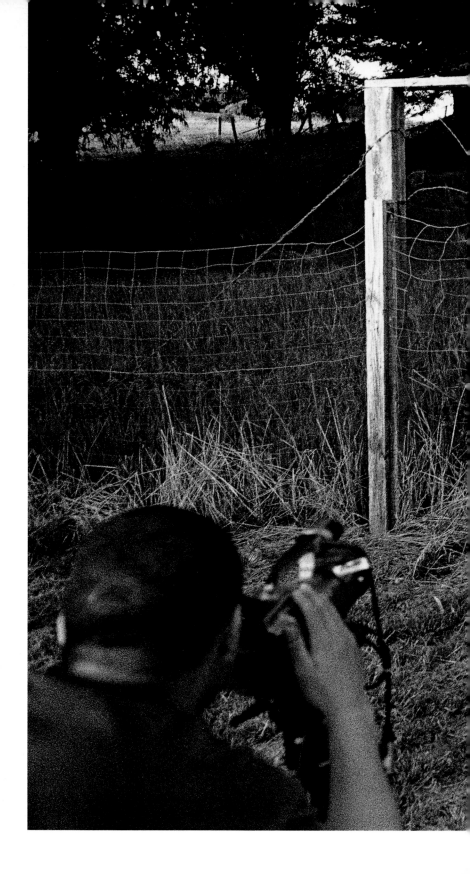

A Beat Within
video
workshop
at Log
Cabin
Ranch,
La Honda

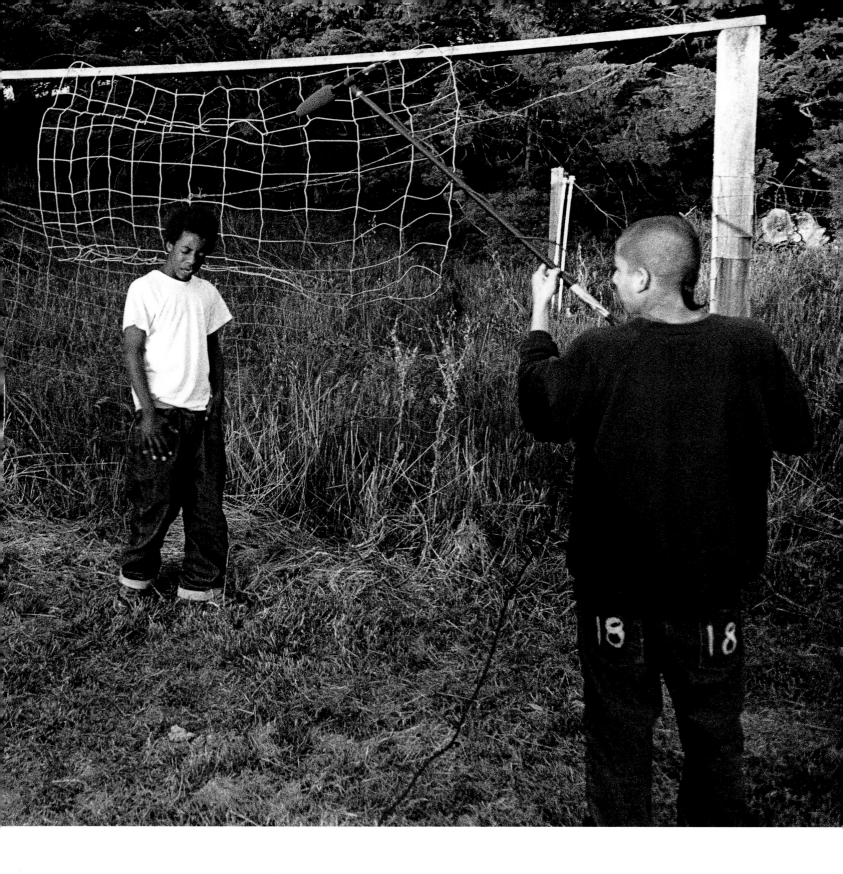

Louie Vasquez

M ARILYN

M ANSON

GOD IS
IN THE
THE TV

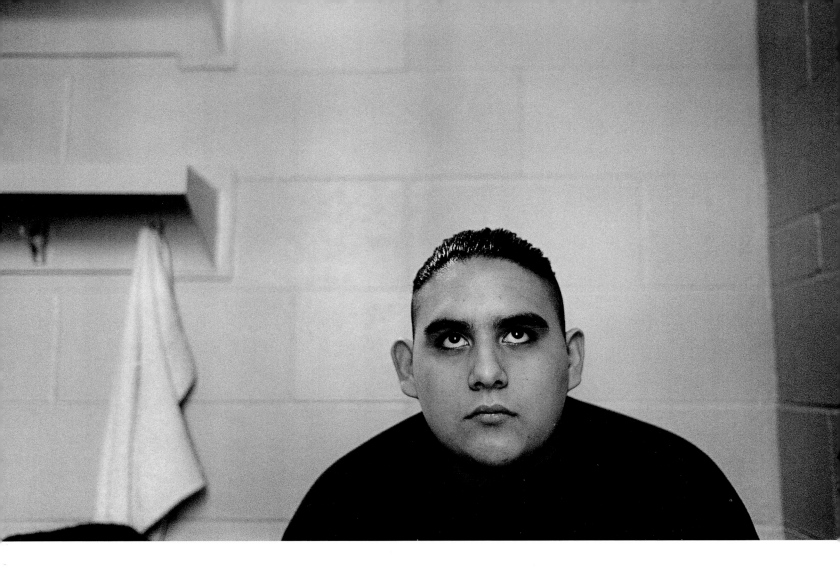

Louie
in his
cell

OPPOSITE:
A page
from
Louie's
notebook

I wish I could take it back.

If I didn't shoot him I was fucked, and if I did shoot him I was fucked—that's what went through my mind at the time of the shooting. Now I'm charged with attempted murder. I have to go to a hearing.

I feel torn, because if I don't kick it with my homeboys, I'll get a bad reputation in here. But it's even scarier to think about being in prison.

BLINKY
Santa Clara County Juvenile Hall
B8 Maximum Security Unit

*View
from
inside
the
juvenile
hall*

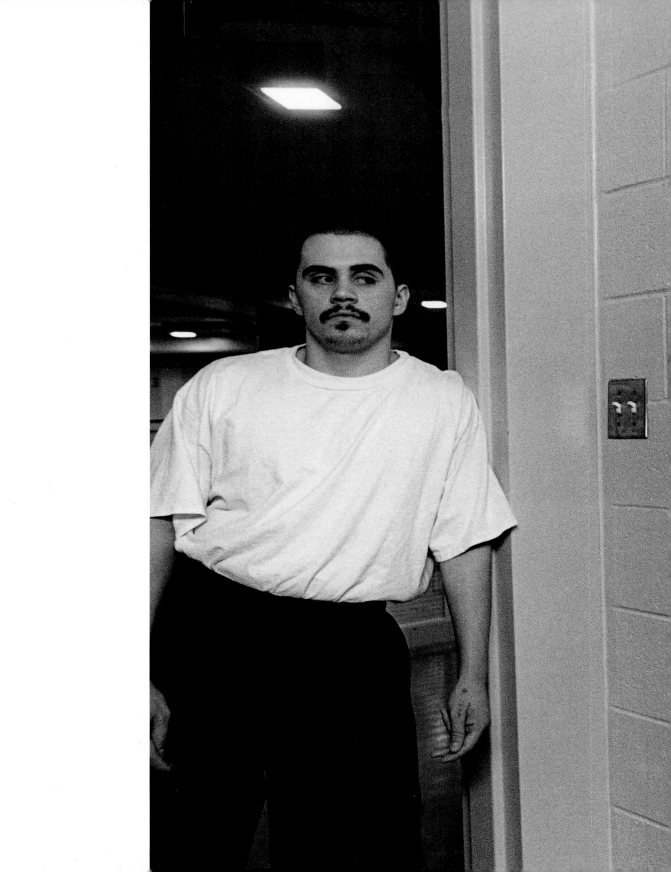

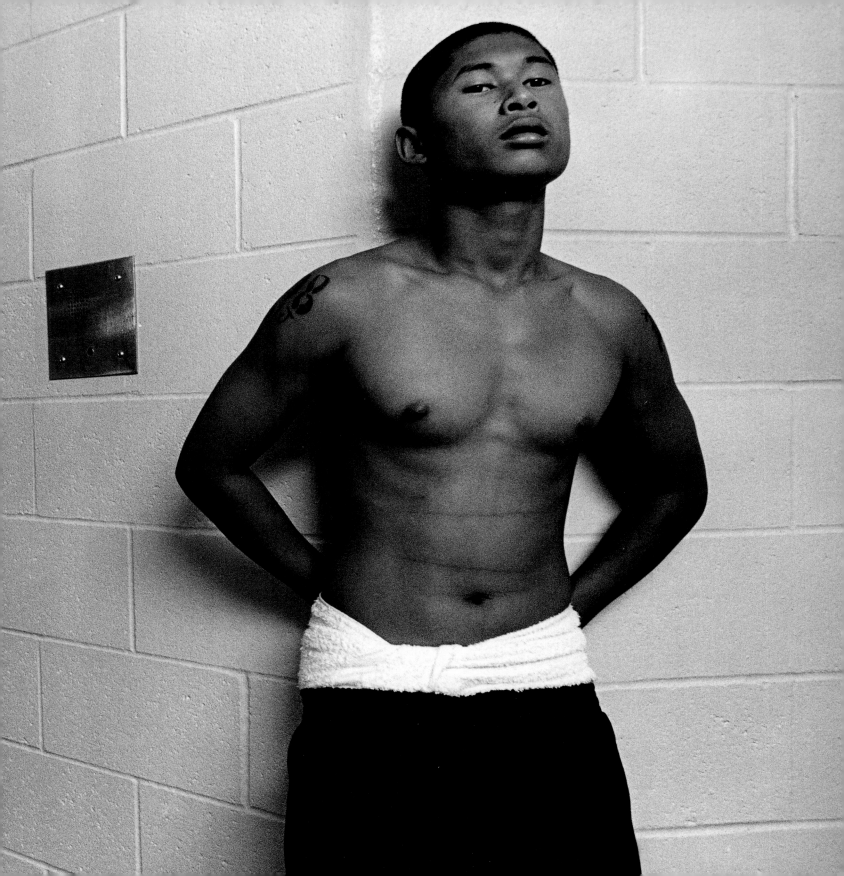

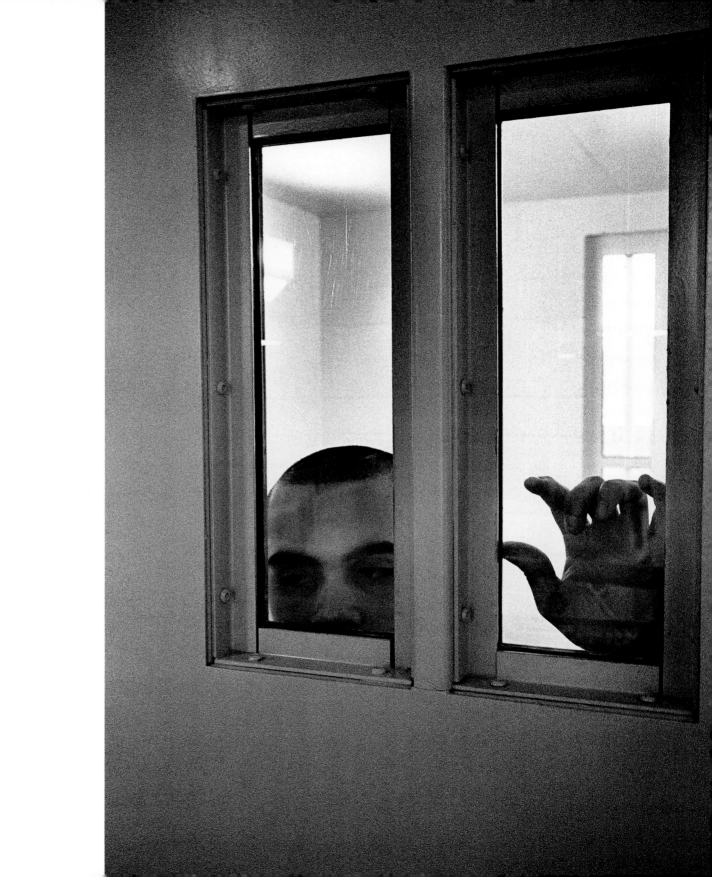

Edward
looking
out of
his cell

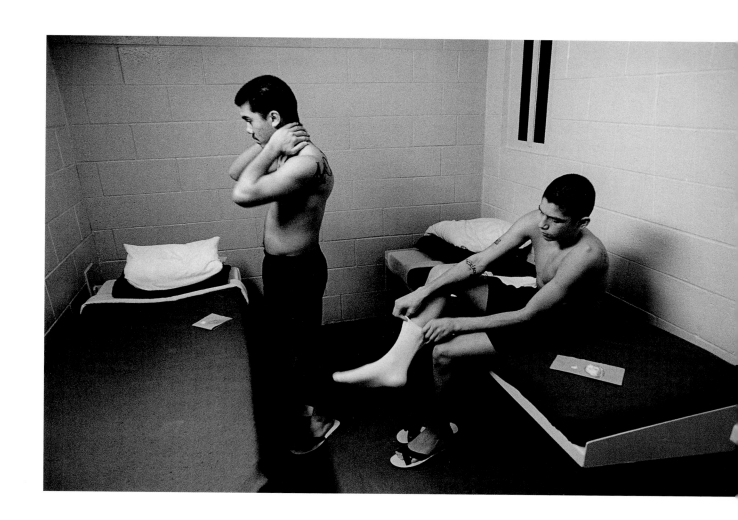

Blinky
and
Ricky

I grew up on the east side of San Jose, on King Road and Story Road.

I remember getting yelled at and getting hit—everything I did was wrong for my dad. I hated him then, but I loved my mom. My dad got locked up when I was an infant, and I lived with my aunt [because my parents were not together]. When I was five years old I went back to live with my dad.

Back then both my parents were smoking PCP and shooting heroin. He used to work nights and I had to watch my younger brother while my dad slept during the days. If we made noise he would come out and hit us. The first time I remember him smacking me around was when I was seven. Through the years I got blamed for everything and suffered for it.

I remember my dad having rocky relationships with his girlfriends. When I was ten, my mom got out of prison, and then it was the same old back-and-forth between my parents. My dad would say that he had my brother and me "in line." My mom would spoil us with candy and McDonald's like normal parents do, but then we'd have to go back to our father because he had custody. And we would get hit again.

I started to rebel in my early teens. I felt I might as well mess up, because I knew I would get hit anyway. Sometimes I would hit my younger brother and take out my anger and frustration on him. I was getting worse in school.

I ran away when I was fifteen, and started doing drugs. I got locked up in juvenile hall—they tried to scare me.

LOUIE
Santa Clara County Juvenile Hall
B8 Maximum Security Unit

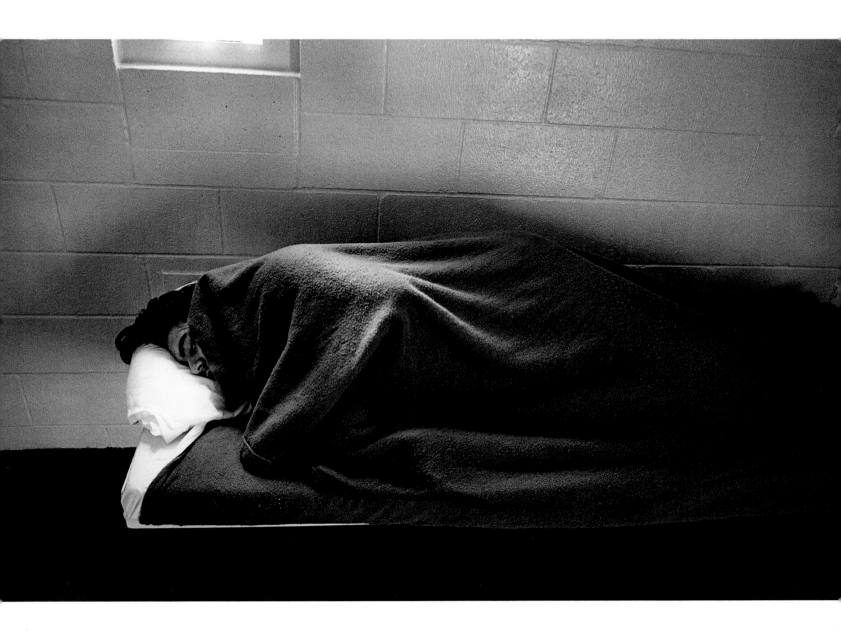

*Louie
asleep
in his
cell*

*A twelve-
year-old
who
kicked
a counselor
is locked
in isolation
until he
can be
evaluated*

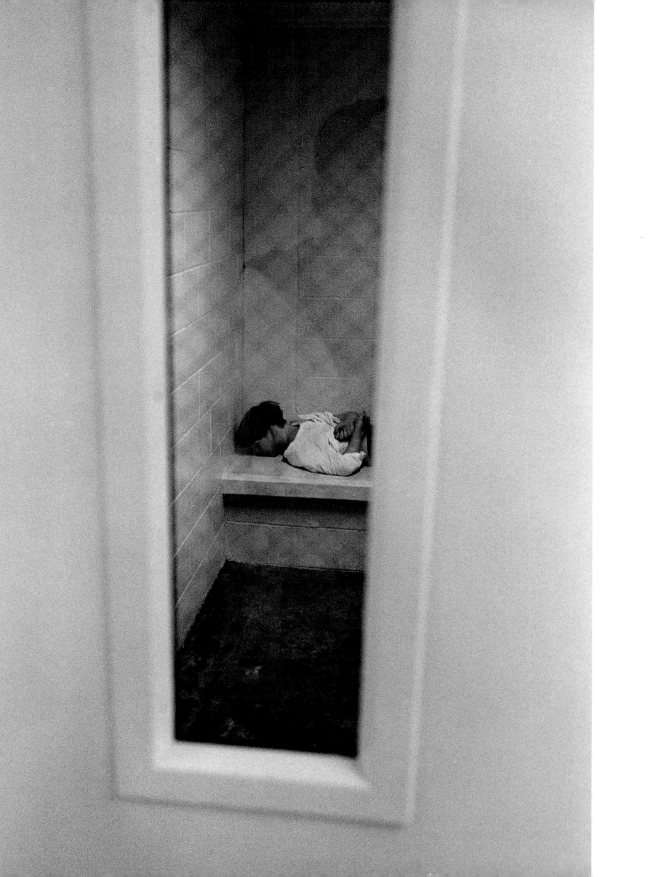

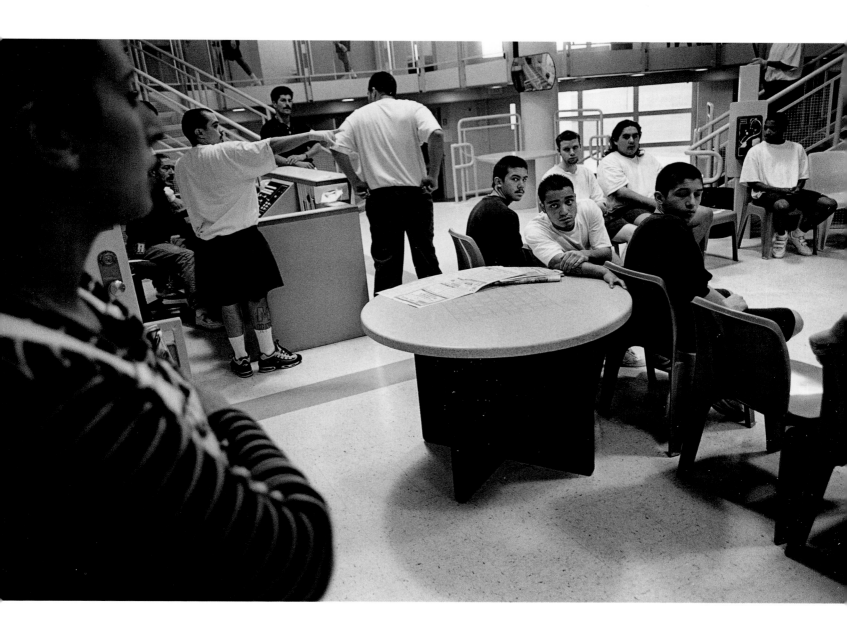

In the dayroom

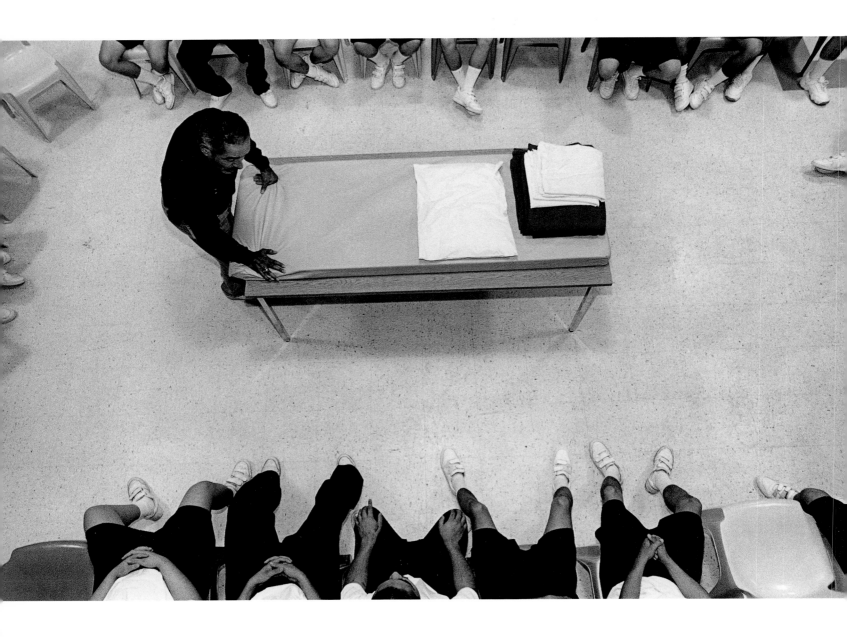

Mr. Sullivan
talks to
the new
arrivals

I am your daddy right now. I am your gang leader. You have to learn how to be a man. You need a firm kick in the butt, but it will not come from me.

First thing you do when you get up is you go to work. You can't lie around and sleep. If you are not ready to go, you will lose your privileges.

Start with making your bed.

MR. SULLIVAN, Counselor
Santa Clara County Juvenile Hall
B8 Maximum Security Unit

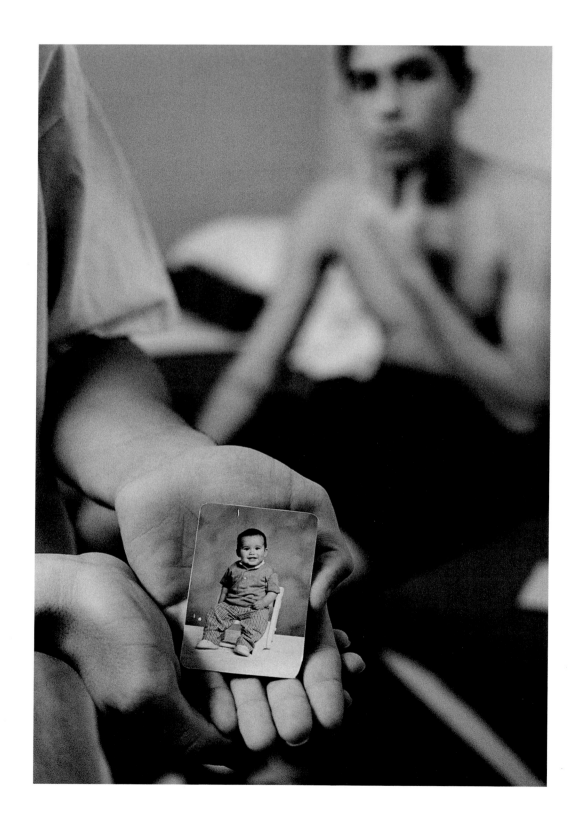

A photograph of Blinky's child. "This is the only way I am going to see my son."

Opposite:
Louie's mother

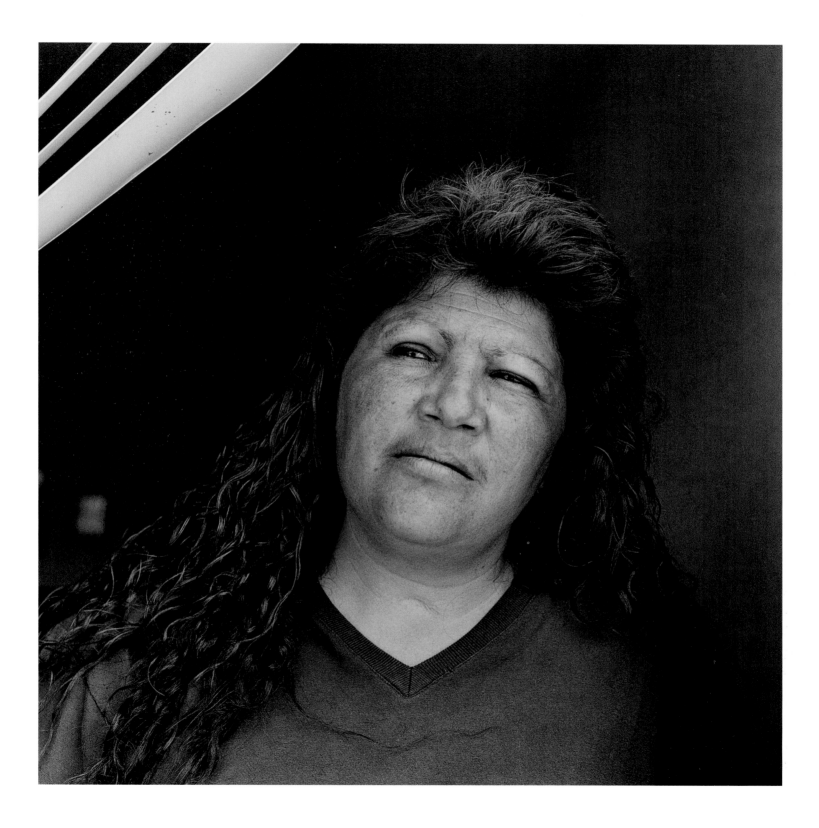

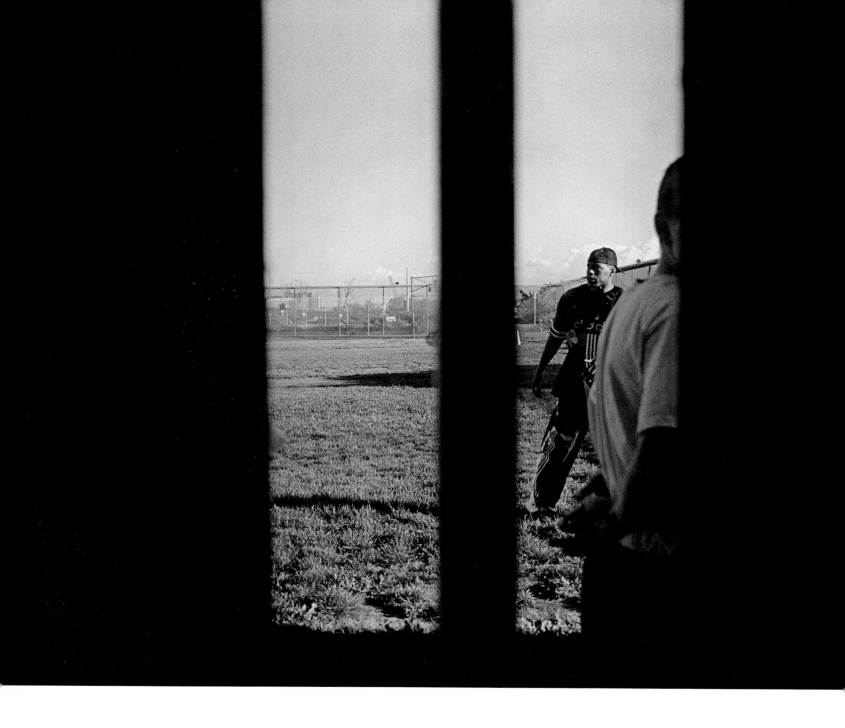

*View
from
Louie's
window*

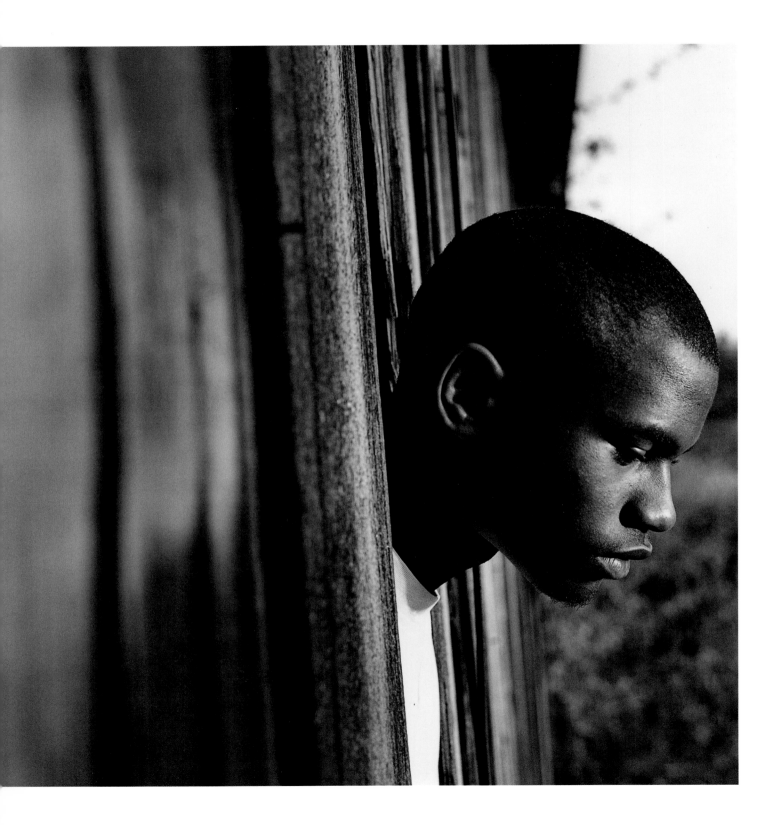

Kethan
looking
out of
a barn
window
at the
Log
Cabin
Ranch,
La Honda

What I am seeing today are the children of people that I worked with back ten, fifteen years ago.

SUPERVISOR ESCOBAR
Santa Clara County Juvenile Hall

*Michael
and his
father,
San Jose*

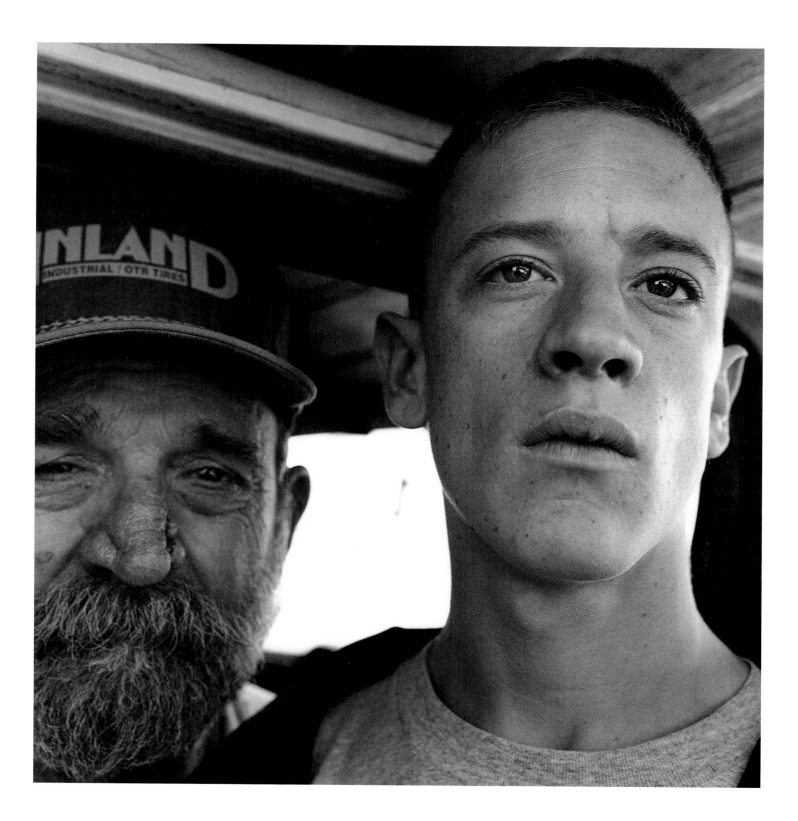

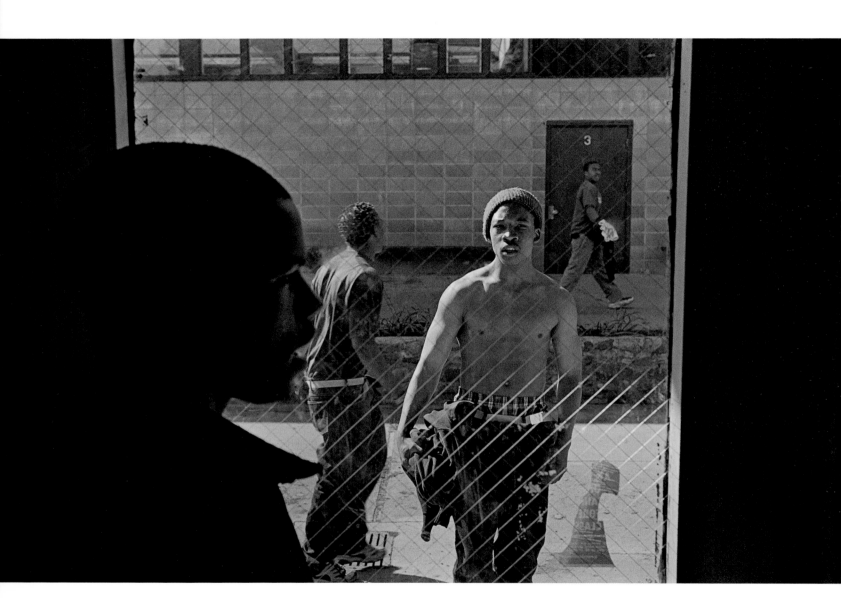

*Kethan
in the
library,
Log Cabin
Ranch,
La Honda*

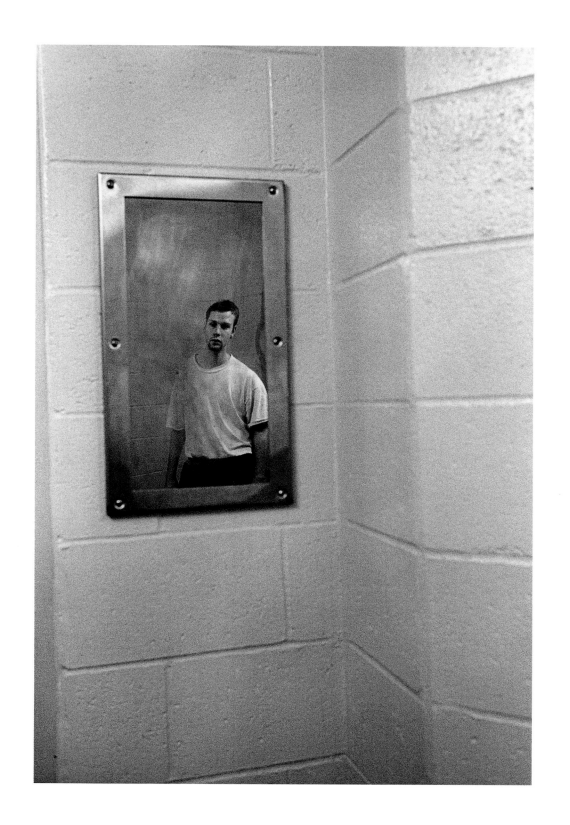

*Chris
in his
cell*

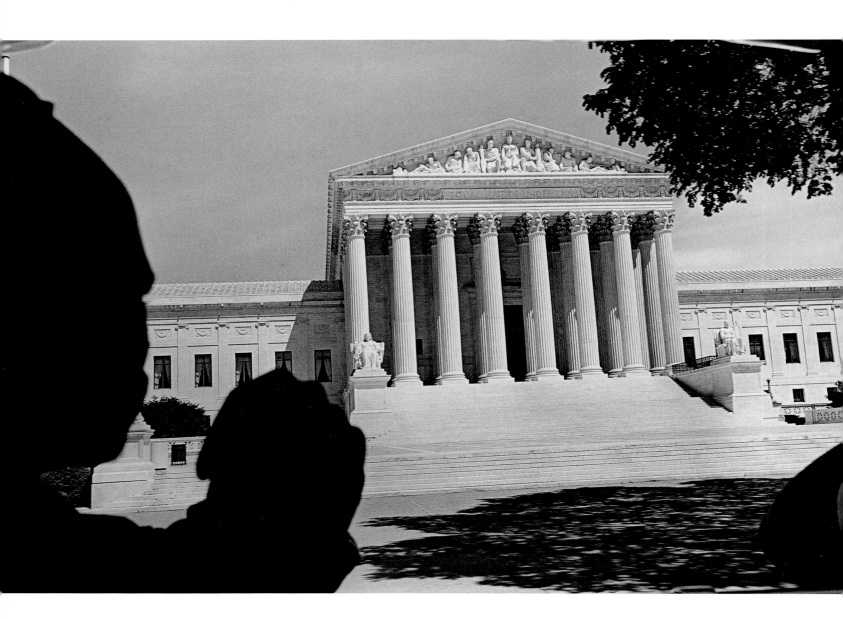

The U.S. inmate population has more than doubled (to nearly 2 million) since the mid-80s, when mandatory sentencing became the hot new intoxicant for politicians. New York (the first state to enact mandatory minimums) has sloshed $600 million into prison construction since 1988; not coincidentally, in the same period it has sliced $700 million from higher education. Americans will have to spend even more in the future to house and treat all the aging inmates. California has already filled its 114,000 prison beds and double-bunks [with] 46,000 additional inmates....In places like New York there are more black and Hispanic kids in prison than in college...more and more young nonviolent, first-time offenders are being incarcerated.

JOHN CLOUD
Time magazine, February 1, 1999

Now
released
from
juvenile hall,
Kethan
travels to
Washington,
D.C. to
participate
in a
national
poetry
slam

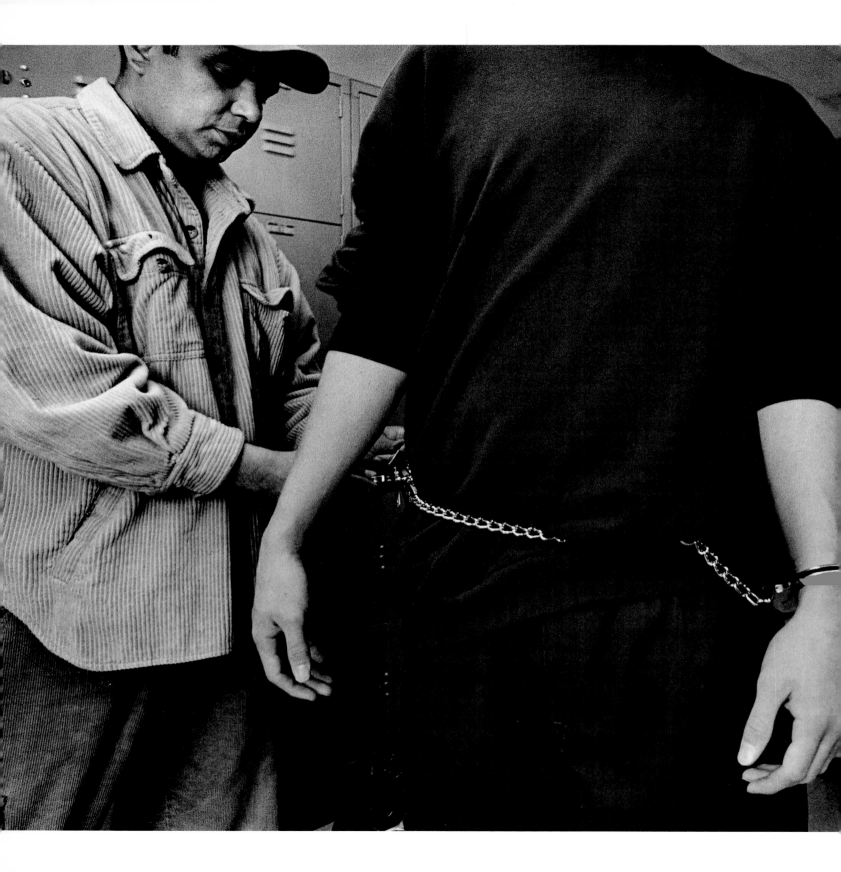

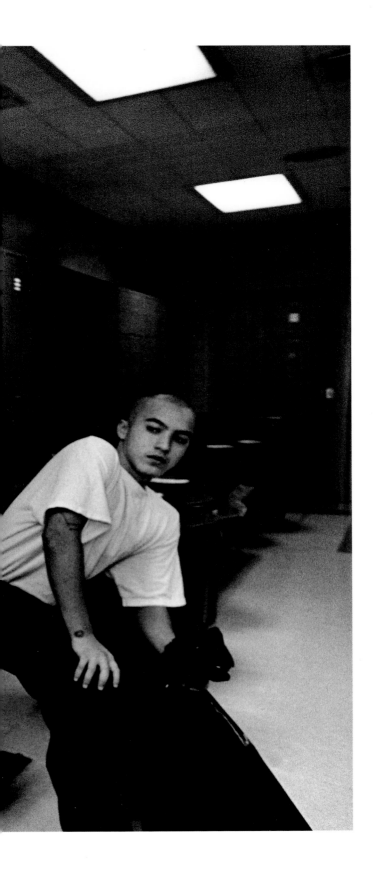

*After
receiving
their
sentences,
youths are
transported
to a
"ranch
facility"*

You sleep all day, Louie. You don't deserve a blanket, because you didn't do anything for it. I am looking for *real men*, not smart-asses. I can't do anything with crybabies. You don't know how good you have it here.

Louie, as long as you don't make any problems, they love you, but they are not going to give you anything.

Edward, you have a 3.0 average, but if you spend thirteen years in an institution, that's not going to give anything. [Edward is a high-school graduate.] Take the free schooling while you have the chance.

Christian, why are you coming back here? Why do you want to duke it out with these kids? You're fighting for nothing. If you don't wake up you are going to keep being warehoused. And every time you come back here, your parents are paying for my pay raise.

The system is thinking of ways to keep you down. They are tired of your ways, and tired of reading about you in the news.

CHRIS PARKER, Counselor
Santa Clara County Juvenile Hall
B8 Maximum Security Unit

Parker asks the kids: "What is power?"
And the kids reply: "Knowledge is power! B8 is the last stop!"

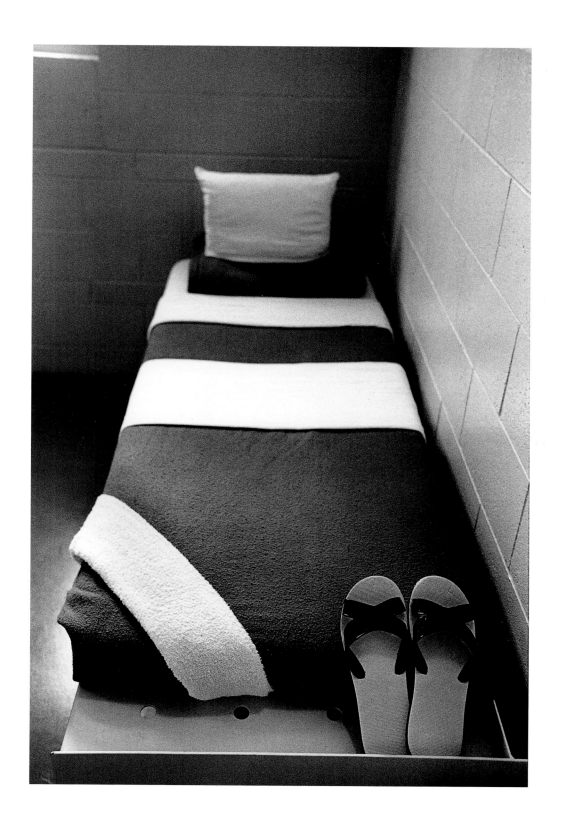

*Cell
cot*

A twelve-year-old, back in his cell after a court hearing

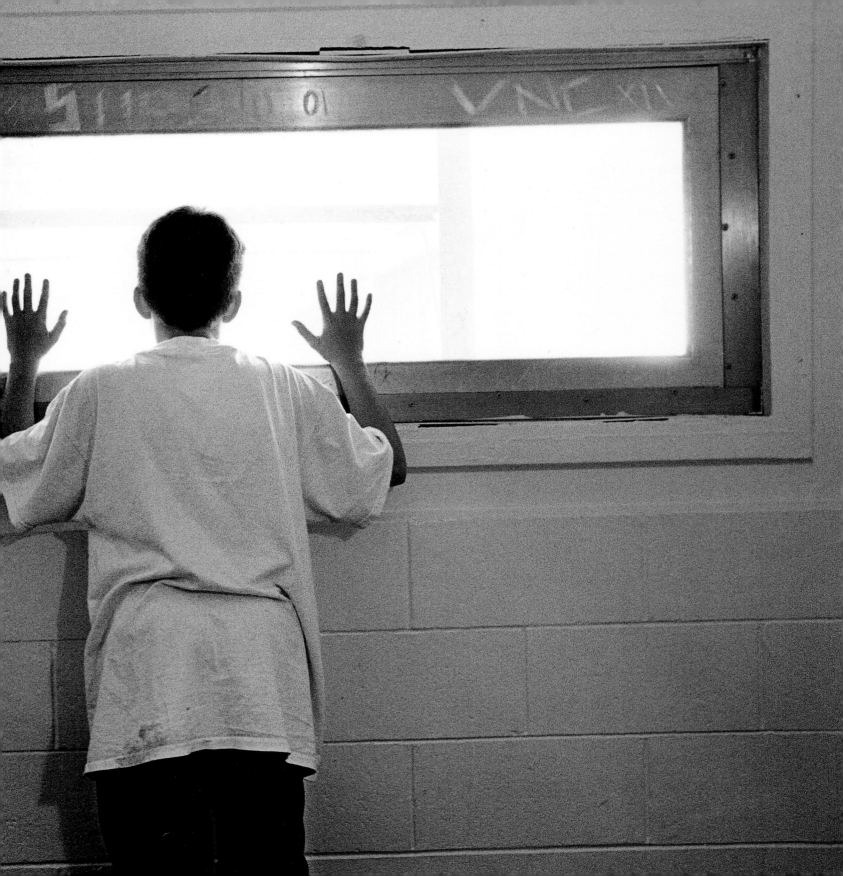

Things have changed here; a lot of these kids are now being tried as adults....

Silicon Valley has a lot of money, but they are not giving any to us, so we have to raise funds. You have to get the eight- to thirteen-year-olds in junior high school—that's where the money should go—to catch them before they get here.

However, it's more humane here [than at other facilities]. We try not to send them to the California Youth Authority. Economics makes everything worse. I turned down a job at the Youth Authority—I couldn't see any hope there. Here I have a chance at making a difference. There is a lot of new blood, and people who are energized with new ideas.

These days the biggest change in the minors is their mental health. When I started there were a lot fewer suicide attempts. Many of these kids suffer with Attention Deficit Disorder, which is associated with drugs and alcohol—children of the 60s generation.

TIM VALDEZ, Counselor
Santa Clara County Juvenile Hall

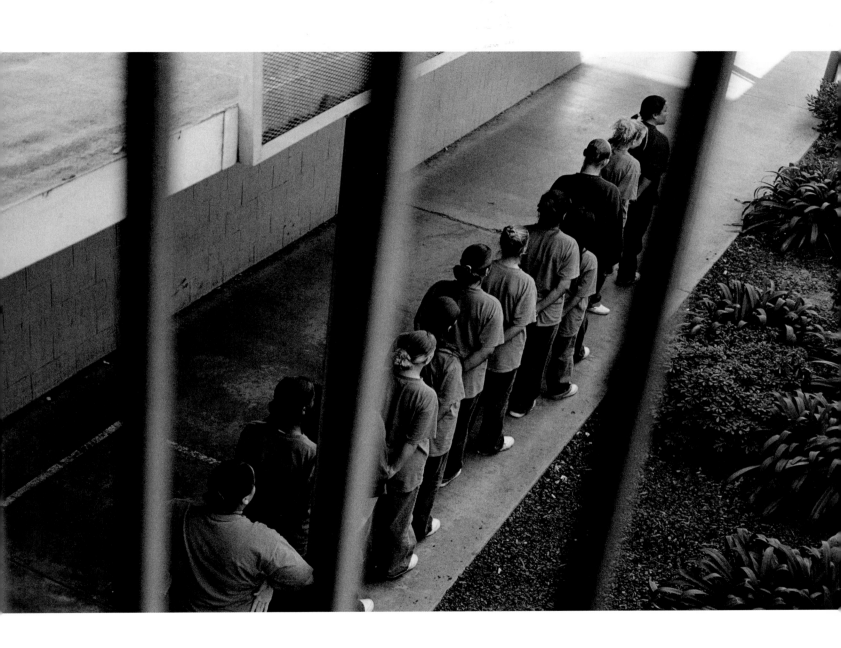

Girls
lining
up on
their
way to
a class

Russell
looking
out
at San
Francisco's
Tenderloin
district

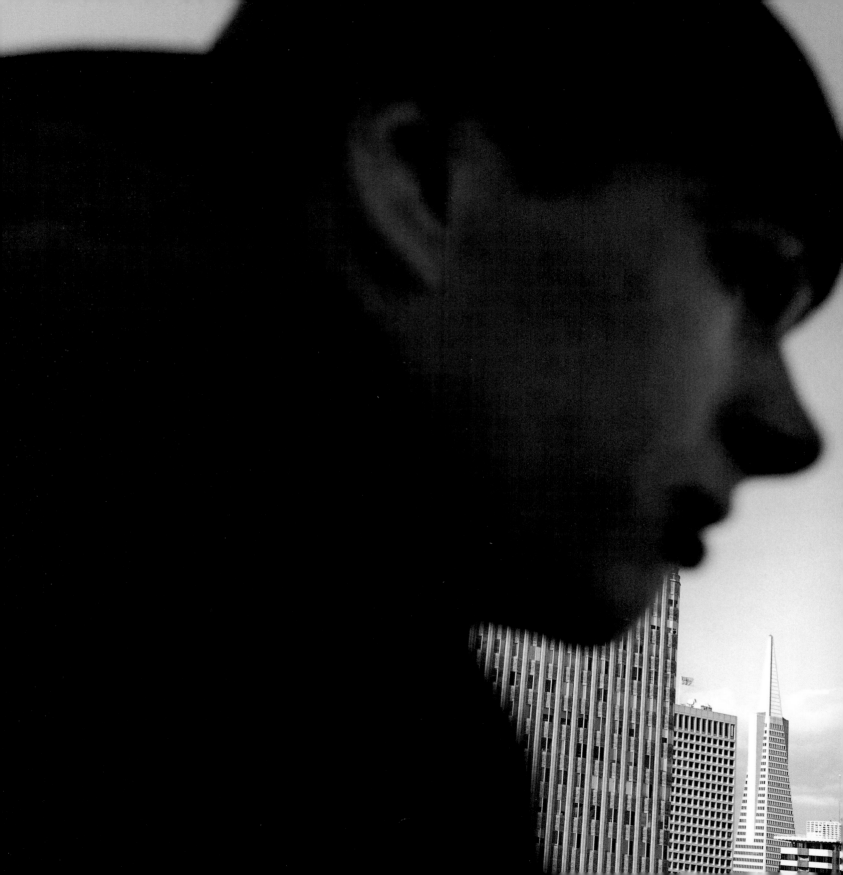

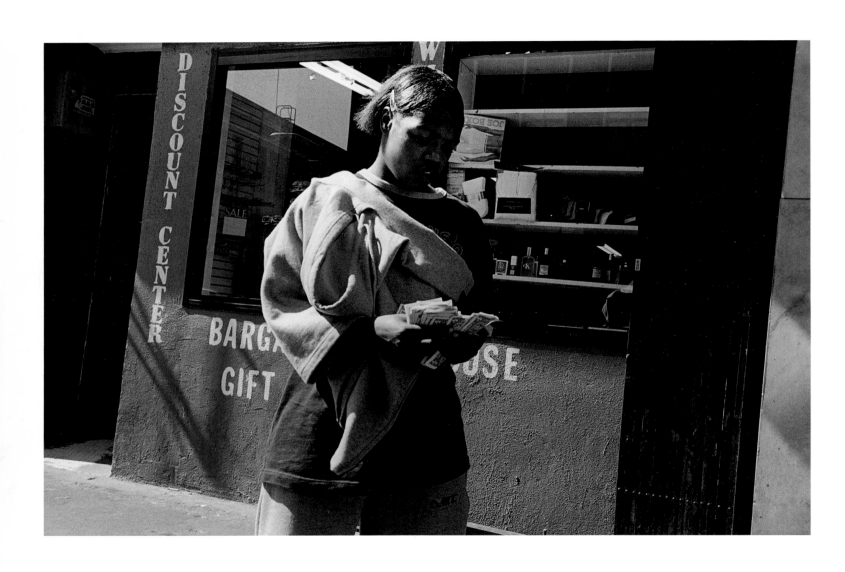

*On a
street in
San Francisco's
Tenderloin
district*

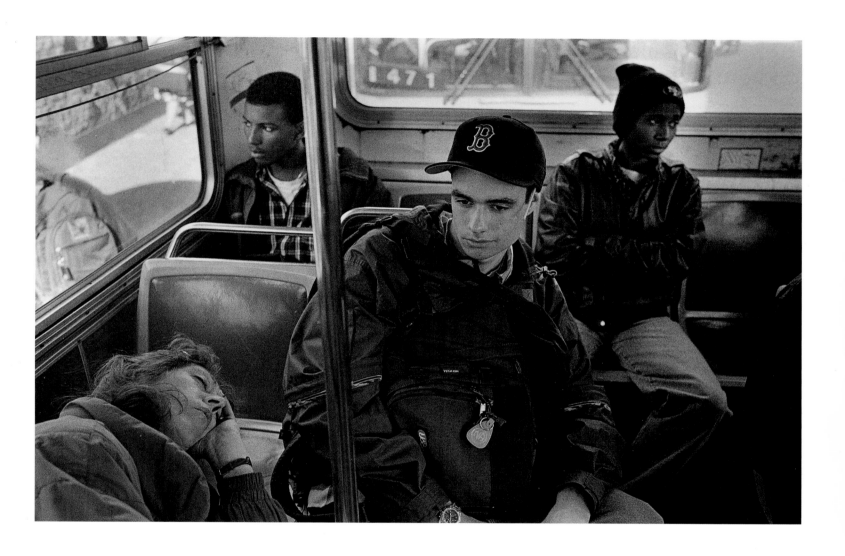

*Russell
taking
a bus
to a class
at the
University
of San
Francisco*

Chunks
of crack
cocaine

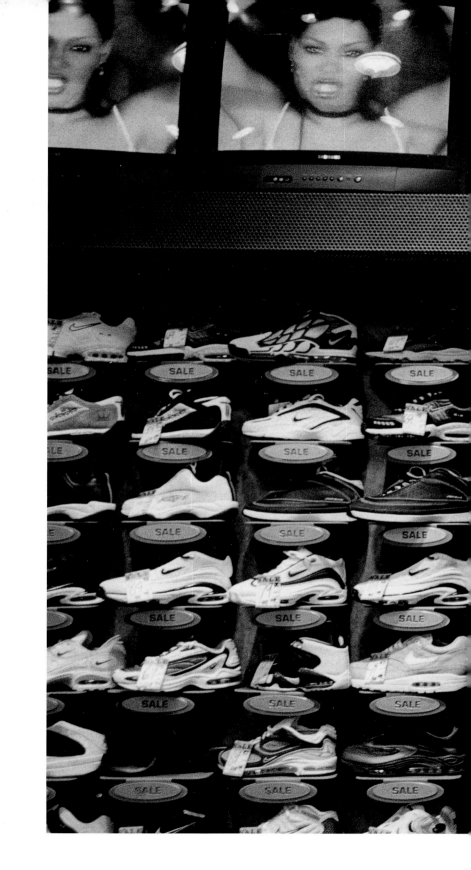

Kethan
shopping
for sneakers
after his
release
from
incarceration

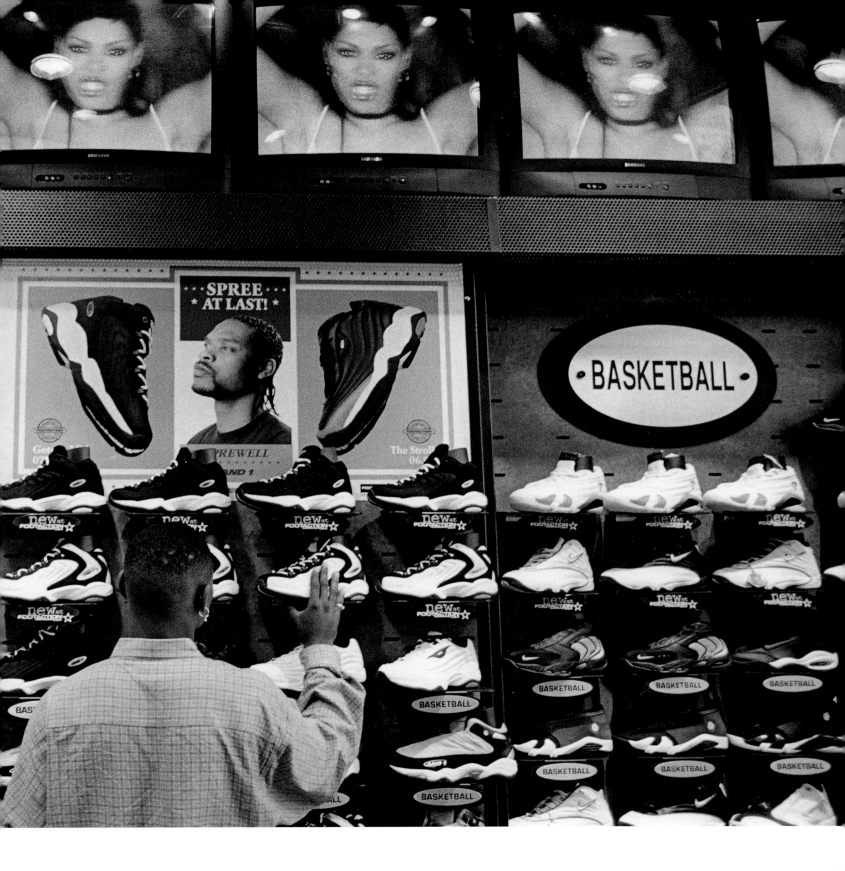

How many times have you been here in juvenile hall? In the amount of time you've spent here you could have studied to be a lawyer. Sometimes I just don't understand—why would anyone want to do a life sentence? You've got your parents locked up also. They're stuck here: they can't just move to another state.

CHRIS PARKER, Counselor
Santa Clara County Juvenile Hall
B8 Maximum Security Unit

Dee Mario
preparing
for a
Beat
Within
writing
workshop

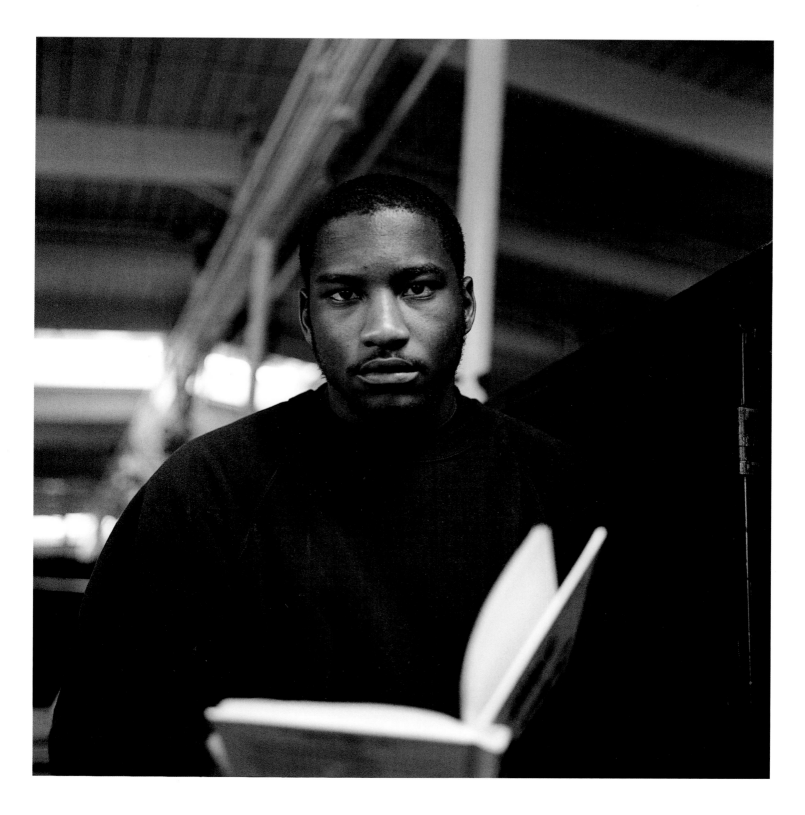

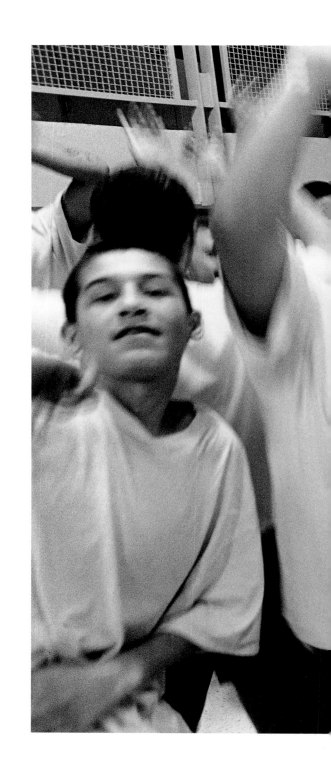

Hip-Hop
Night
in the
dayroom

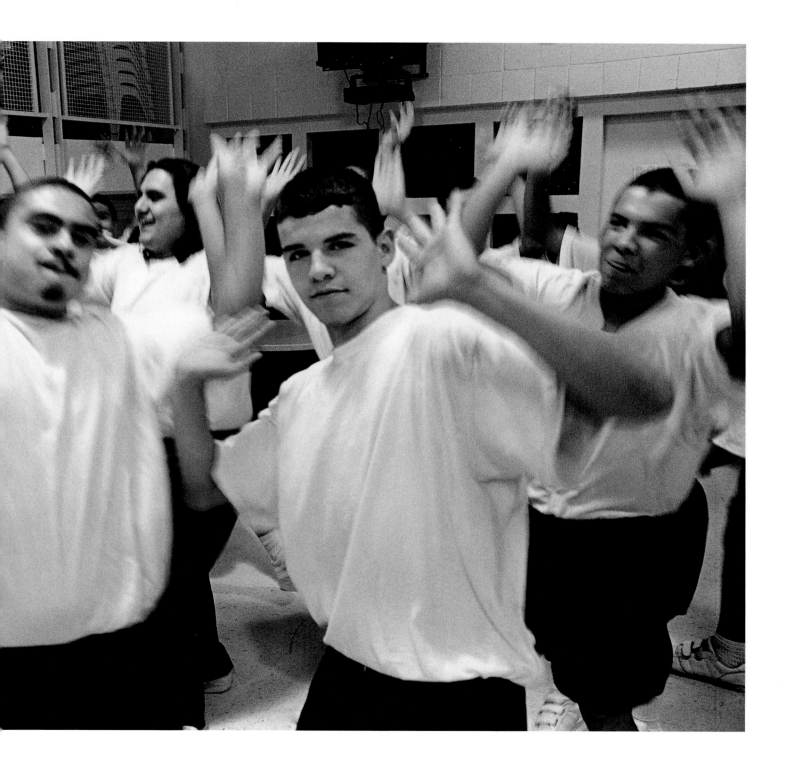

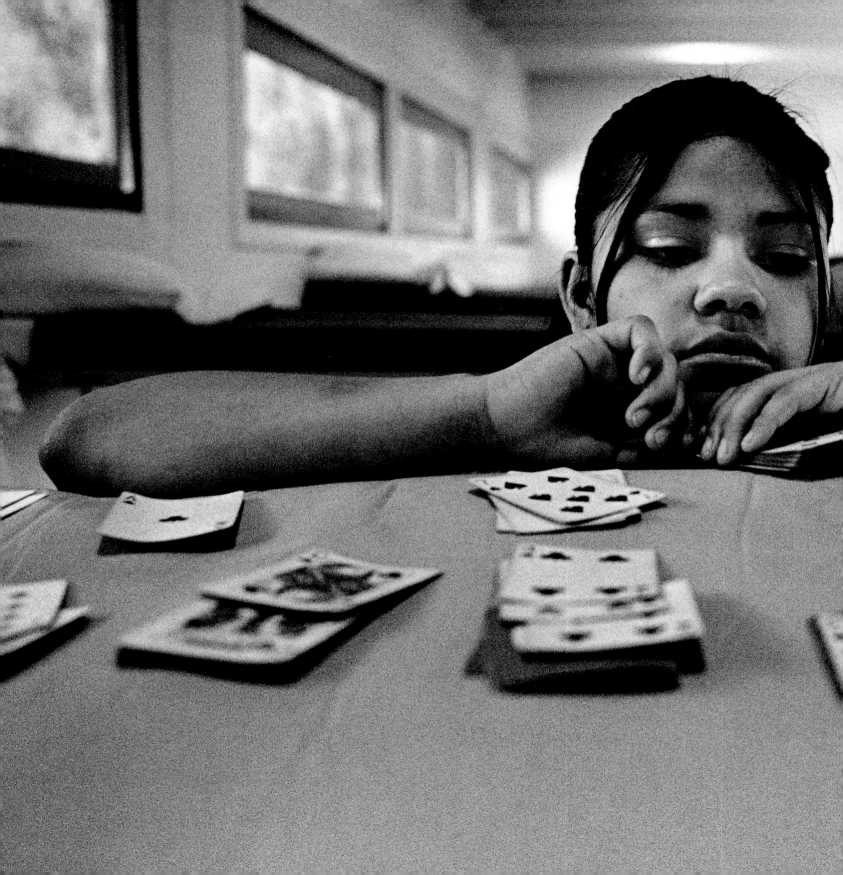

*Katrina
playing
solitaire*

What are some things I like about myself?

Are you being forced to attend this school?

What is your atmosphere at home?

Describe your mom and dad.

What are your views on drugs?

Questions on an evaluation form for the Crossroads School, an alternative high school in San Jose

Katrina outside the "EE" group home, San Jose

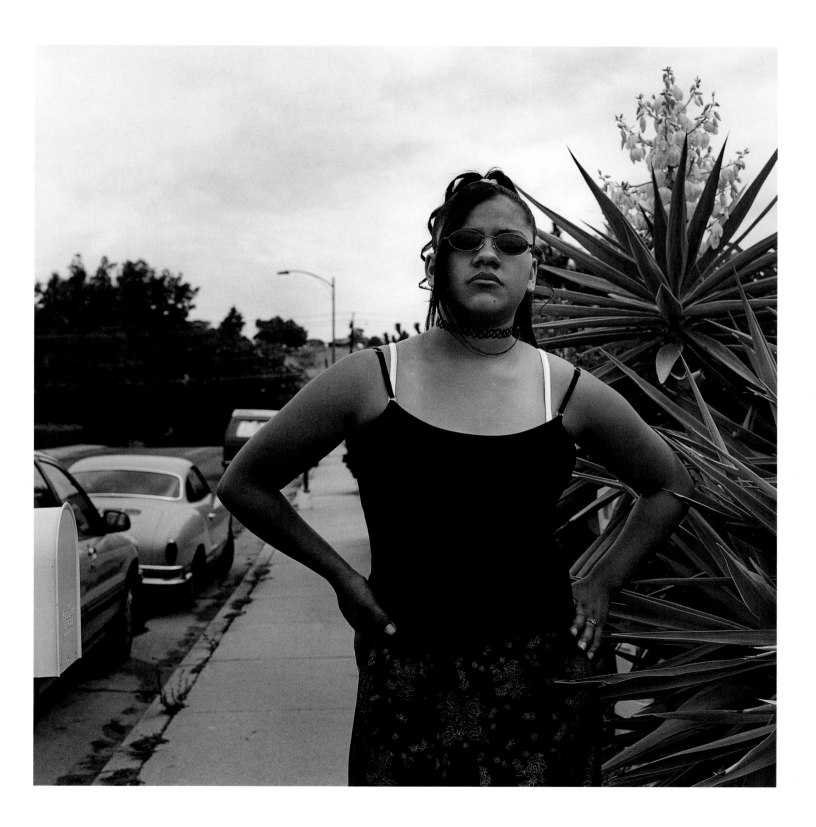

I haven't seen my mother for thirteen years.
I decided to mutilate myself.

ANONYMOUS
Santa Clara County Juvenile Hall
B8 Maximum Security Unit

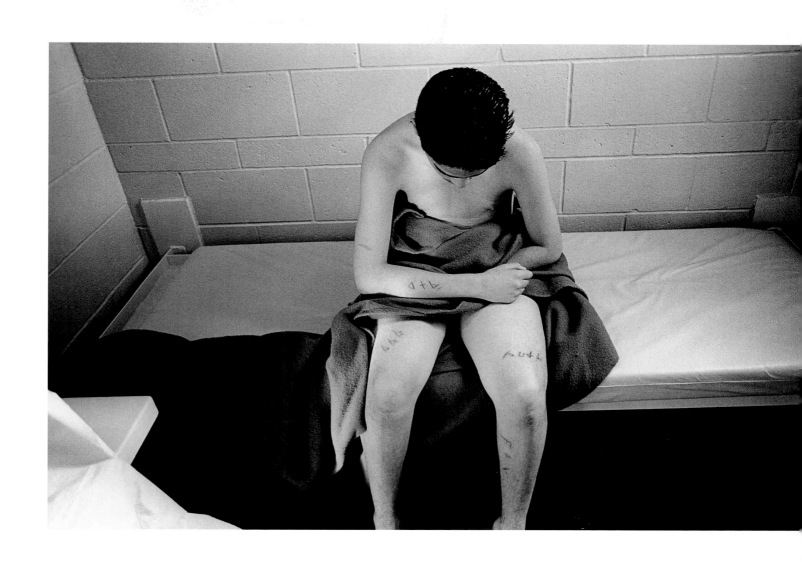

This boy, a self-mutilator, was declared a high risk. After a psychological evaluation he was transferred to a lower-security unit.

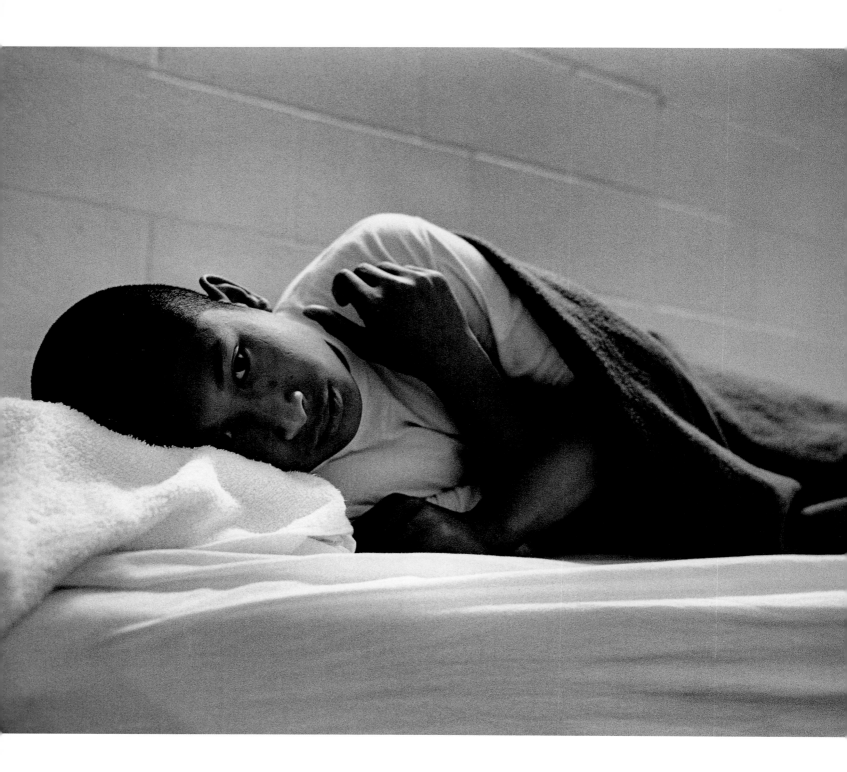

We are Vietnamese and Cambodian. We are stupid—because we fight with each other; we war with other Cambodians.

After I threw a rock that hit a rival gang member in the head, I thought about a lot of things. I hope the guy is going to be all right.

All my brothers are in the system—with the Youth Authority, and in group homes. I am the youngest. I am sad, because I was doing good, going to school. I have really hurt my parents.

SOVANNY

Sovanny in his cell

*Yao Hay, Sovanny's father, was a lieutenant in the Cambodian army in the
1980s. During a Vietnamese invasion, he escaped from Battambang and
made it over the Thai border, where he was abused, harassed, and beaten by
Thai soldiers. The UN Human Rights Committee placed Yao in a refugee
camp, where he met his wife.*

*In 1981, a month after the birth of their first child, the couple was
brought to the United States. It was snowing when they got off the plane in
Kentucky; it was colder than anything they had ever experienced. They
heard from a friend that California was warmer, so they moved to San Jose
in 1982.*

*"I used to be afraid of my son being hit by a car," Yao says. But as
his children got older, his fears turned to the gangs in the area. They were
smoking marijuana, and pissing on the walls.*

*When Sovanny was twelve he started engaging with gangs and
coming home late; sometimes he didn't come home at all. He was first
arrested for smoking marijuana. His oldest brother was involved in a
shooting and was transferred to the California Youth Authority. Sovanny's
brother was sent to a group home to work on his "anger issues;" he is now
taking medication and doing better.*

**My kids would not have been in such trouble if they were disciplined. In
Cambodia they discipline kids with family activities, like working in the
rice fields. Society is taught that it's right to respect your parents. We have
a close relationship with the teacher and the family. In Cambodia, you
respect your elders. In the United States, the child is feared by their parents.**

**When our boys were younger their mother used to discipline them,
until the teacher told us that we could be sued and our kids could be taken
away from us. There was one incident, when one of my boys stole some
candy. When the police brought him home, they warned me not to hit my kids.**

**I would like to go back home to the countryside. But at my age I can't do
farmwork anymore. I don't have any other skills.**

YAO HAY

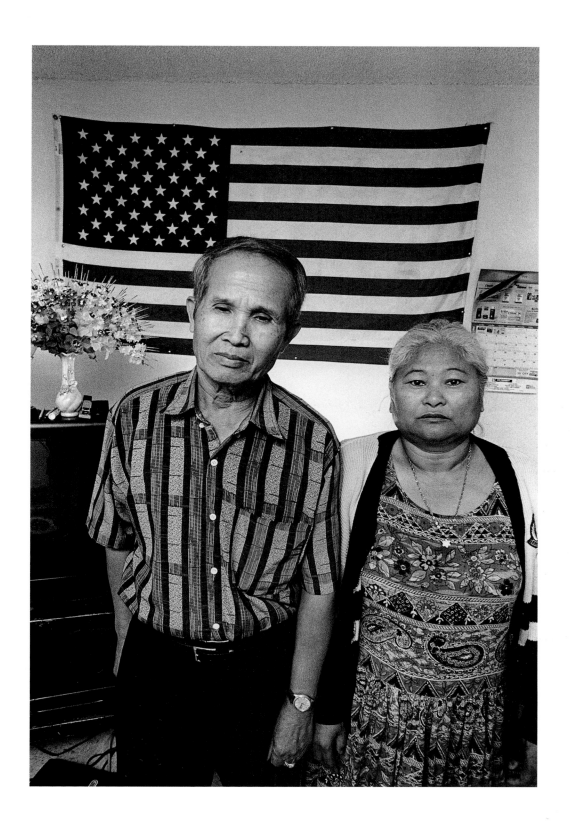

*Sovanny's
parents*

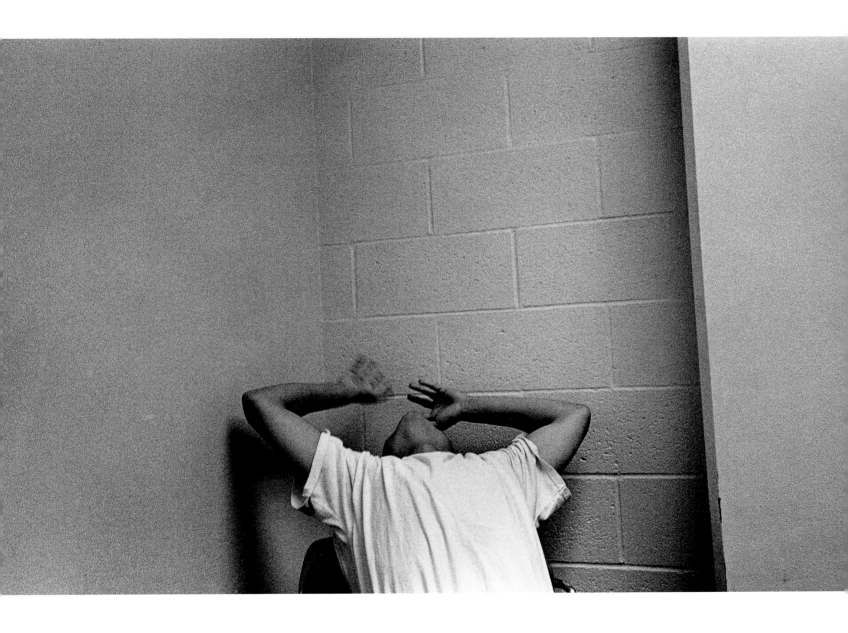

José,
nervous
before
a court
date

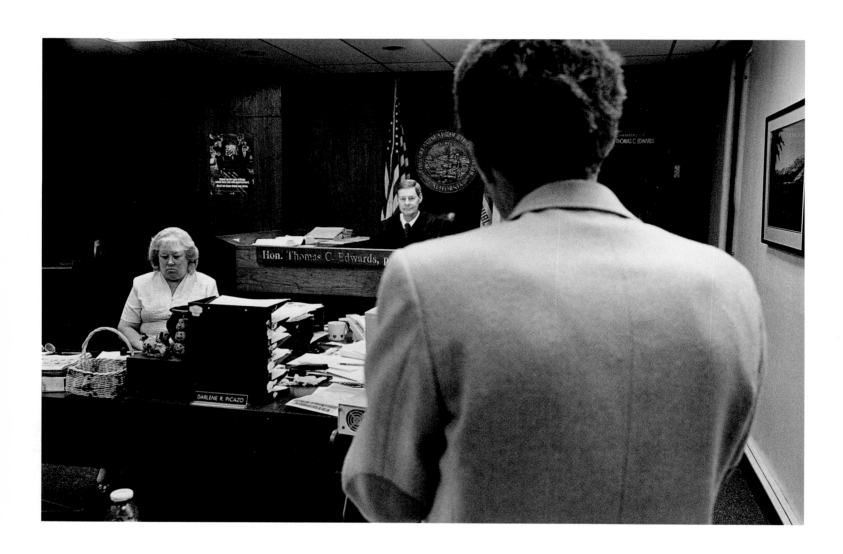

Judge
Edwards
speaking
to the
district
attorney
about
José

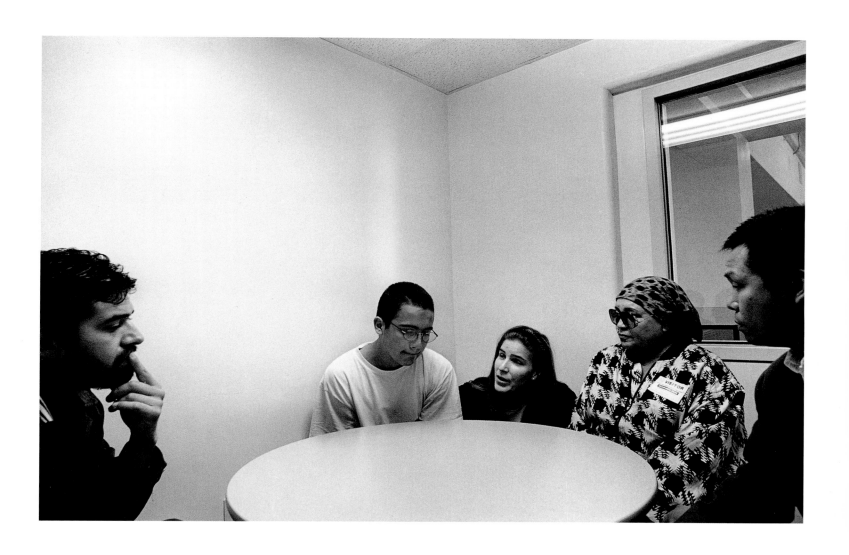

José meets with his group of supporters: a mental-health worker, a public defender, his grandmother, and a probation officer before going to court

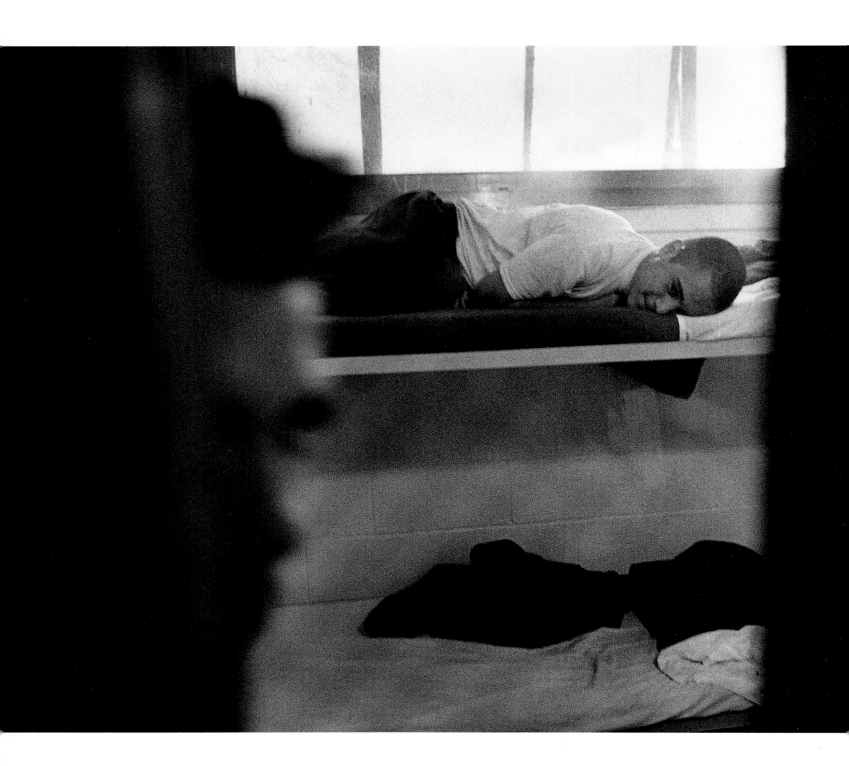

José,
back
in his
cell

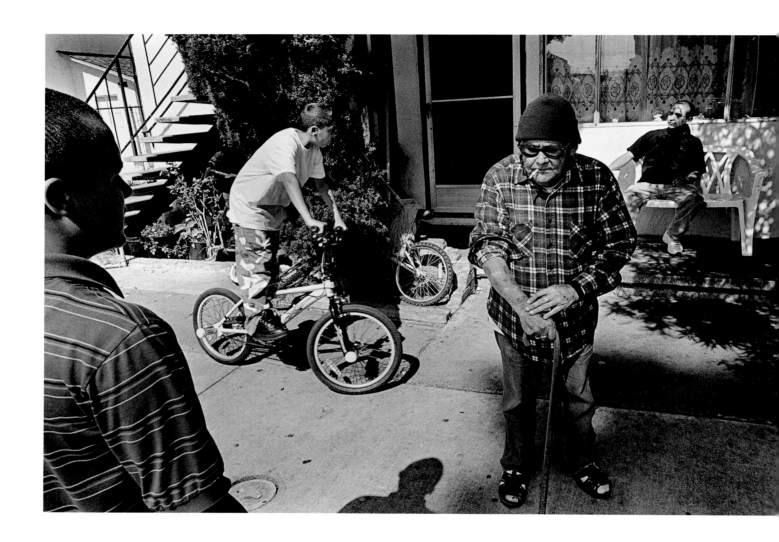

*José at
home with
his family,
San Jose*

Opposite:
*José doing
homework*

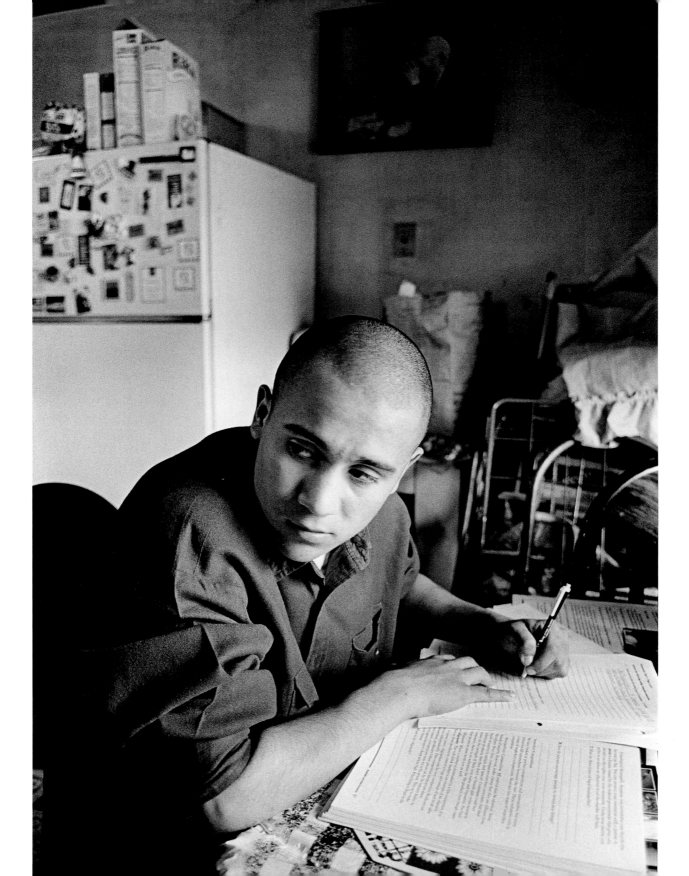

I was thirteen years old when I did my first burglary.

In the last three days I've had four hours of sleep, because my son, Charles, Jr., has been sick. He suffers from asthma. I think it is important to be with my son as much as possible. When Krea, his mother—she works fifty hours a week—and I were both working, we would just meet up as a family at the end of the day. And we can't find daycare—the daycare we do find costs too much money for us. So we decided that one of us would stay at home to take care of our son.

I can remember when my parents had to work and I wouldn't see them. I don't like my father because he disappeared from my life when I was young, and when he came back to my mother, he would always criticize her.

Nobody will ever say that I wasn't a father to my son. Marriage is a deeper thing than just love. I ask myself: "What does your child need?" Your guidance, your experience, and your love.

We can't all rap, hoop, or dance our way out of our situation. *YO!* [*Youth Outlook* magazine] got me interested in writing. Today I am a journalist writing for the Pacific News Service. I have been with PNS since 1995.

CHARLES

*Charles
and
Charles, Jr.*

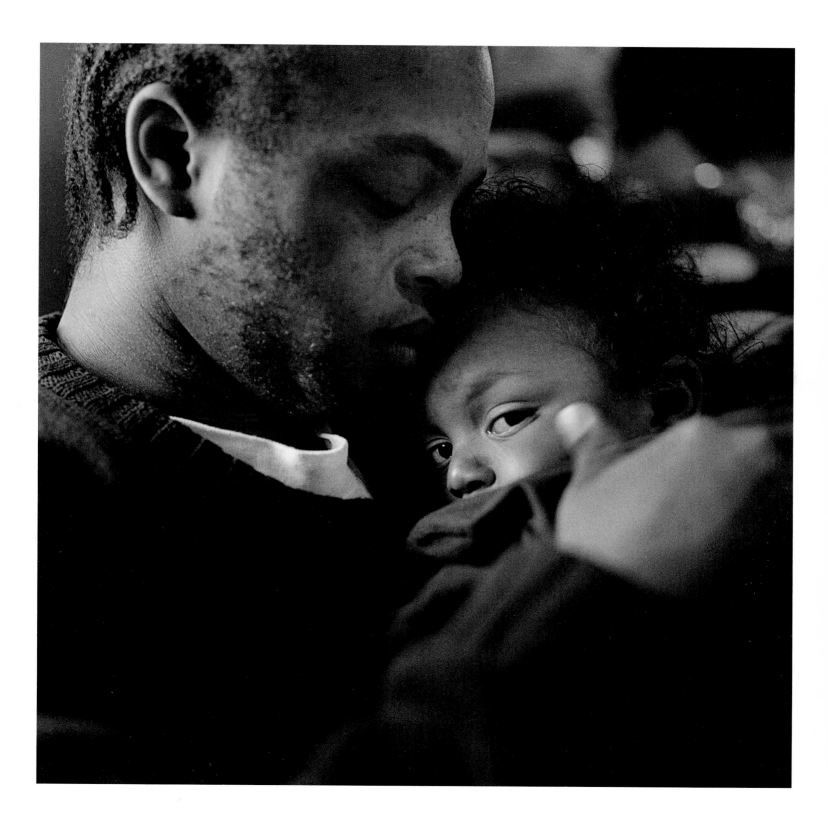

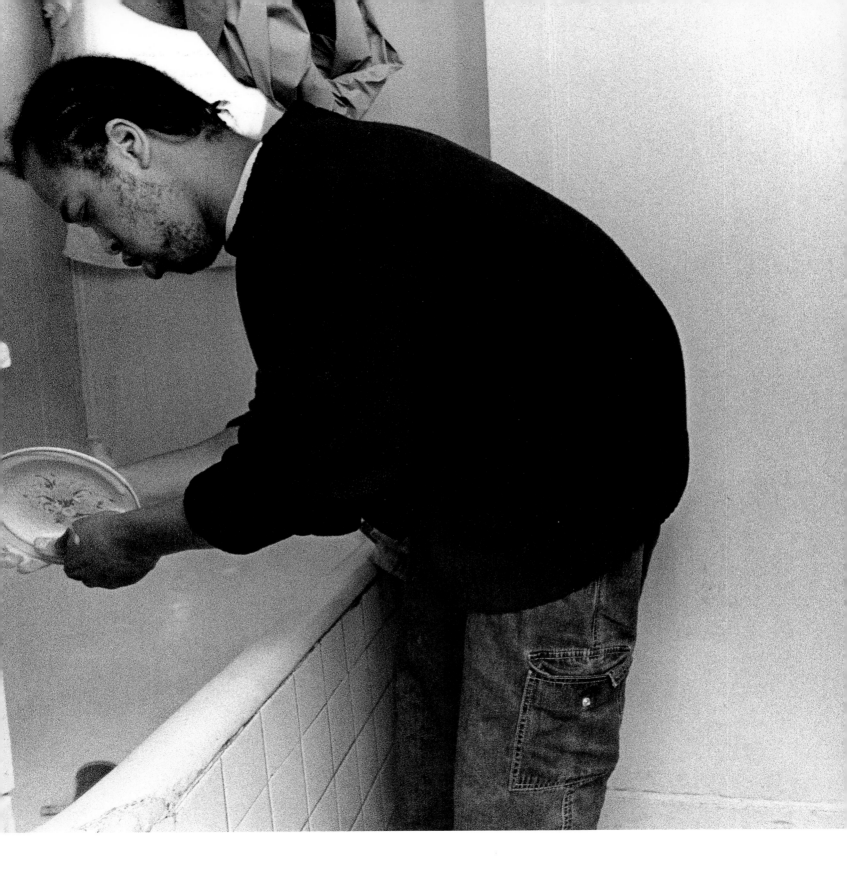

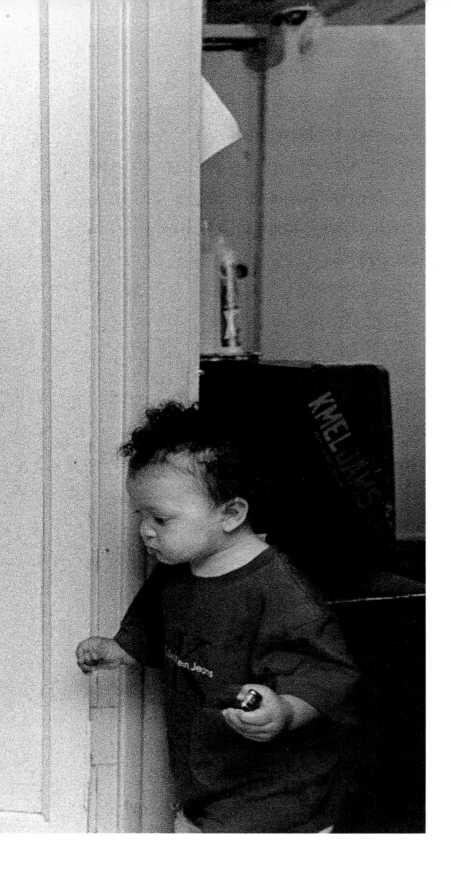

Charles and I left our place in Oakland because the apartment was not safe for children. We couldn't cook and wash our dishes, because the kitchen was not in good working order, and the landlord did not want to fix anything. There was also mold growing in the kid's bedroom, which made our son's asthma worse. It just wasn't livable.

Early on, I told myself that I would never go on welfare—it's the reason so many kids wind up messed up. It sets you up for failure. The responsibility of taking care of my family is what I want to teach my children. It's a state of mind.

I beat the statistics. I went to college while I was pregnant. Charles and I don't take welfare and we don't sell drugs.

KREA

Charles and Charles, Jr., Franciscan Hotel, San Francisco

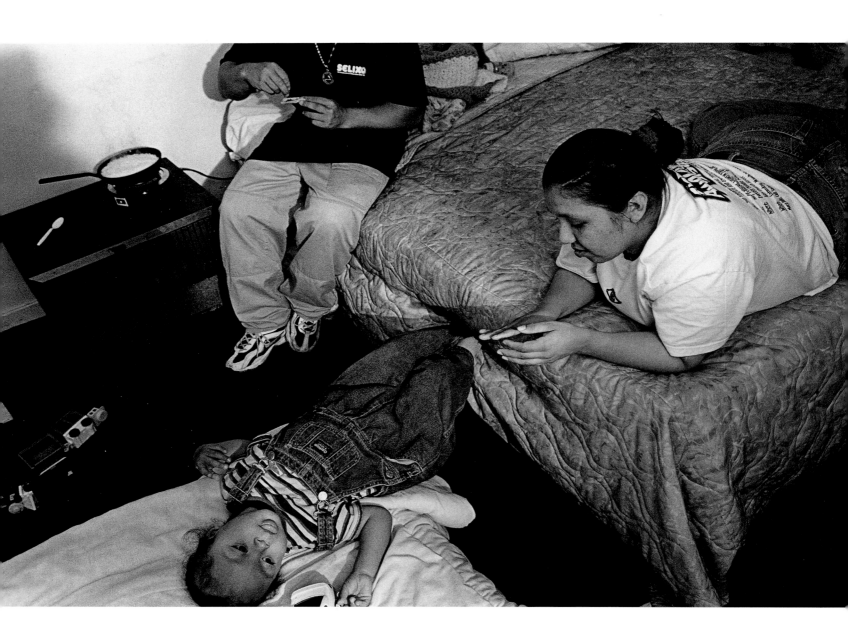

Krea, Charles,
and Charles, Jr.,
Franciscan
Hotel, San
Francisco

I know that in five or fifteen years I am going to look back and laugh at all
this shit. I have been depressed lately, because I have been sending out
resumés—and we don't have enough for daycare, which costs $495 per child
per month. The average is $600–$700 a month anywhere in Oakland. There
is another daycare that is cheaper with the Children's Council, but the waiting
list there is three and a half years!

We just can't save enough money.

Right now, we are getting vouchers from a Christian agency—it enables
us to stay in this hotel for a week at a time, and at the end of the week we
have to call in for another voucher to stay for another week. It's like a lottery:
first come, first serve.

KREA

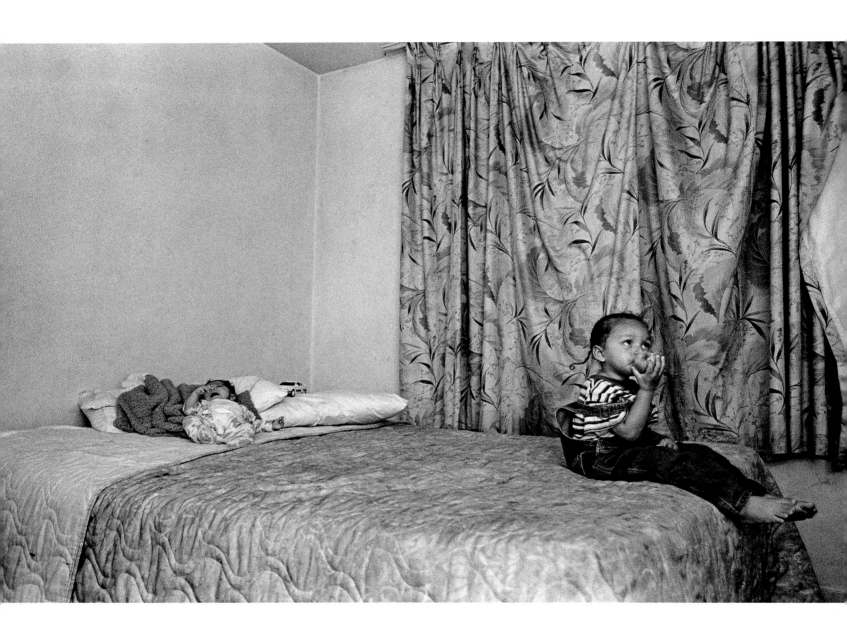

*Charles and
Krea's children,
Ajaya and
Charles, Jr.,
Franciscan Hotel,
San Francisco*

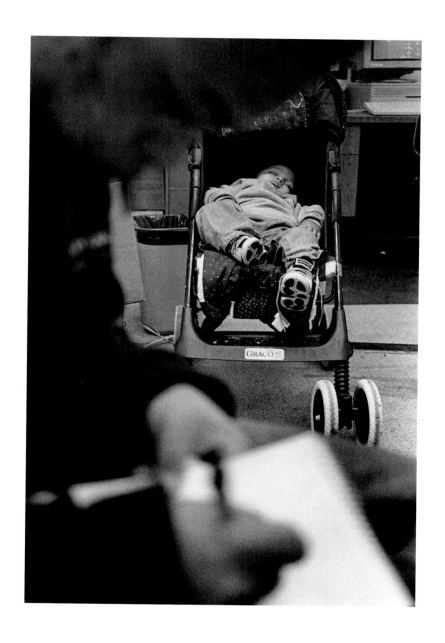

Charles
on deadline
at the
Pacific News
Service

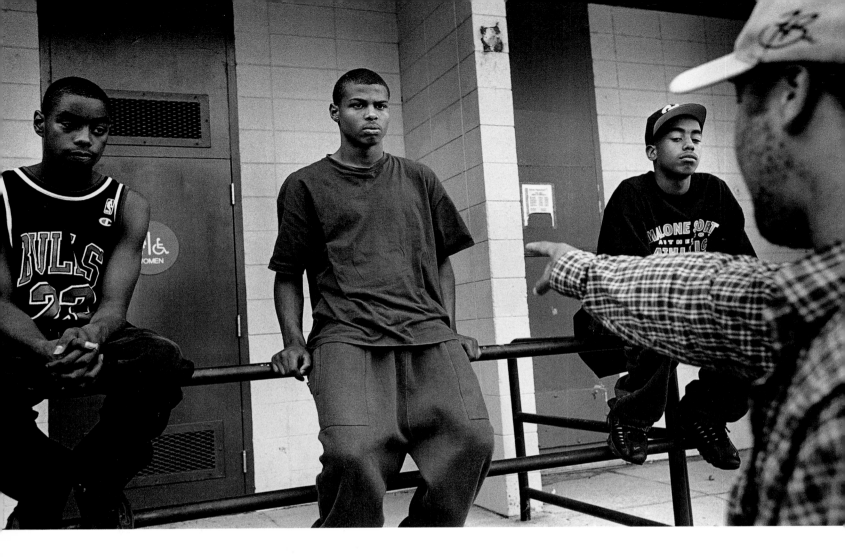

Charles
warns
local youths
about the
terms of
Proposition 21,
Hunters Point,
San Francisco

I never went to juvenile hall, but I did go to school with guns. I am one of the few people from my 'hood that stayed out of the justice system.

I used to deal weed and cocaine. My mother did heroin and smoked crack. My father turned my mother onto drugs—she figured this was a way to keep him home, so she gave herself to the drugs. She was trying to be a good wife, which is why she stayed with him.

In 1980 I was four years old. My mother and father were having an argument. I knew that my father had left his .38 snub-nose gun in a drawer in their room, so I picked up the gun and went downstairs, where my father was beating my mother. I remember like it was yesterday. My little brother was one month old; he lay in his crib. I walked into the kitchen, held up the gun, and pulled the hammer. I shot at my father, but missed and shot myself in the hand.

I never cried.

I never really liked my father, but I grew to love him. I respect him, 'cause he would go to jail for stealing food for us. His philosophy: "There is no such thing as a right and wrong. There is just survival."

College can get you out of all this. But a lot of time must be invested in your education. You might be recognized for your efforts, but you are not necessarily going to be noticed for your talents.

CHARLES

WONDER BREAD

BY KETHAN HUBBARD

I was the thug that always had a sensitive side and will always have one.

I was the kleptomaniac that everyone came to for stolen goods.

I was the frightened little boy who heard gunshots

while entering the corner store for a loaf of bread.

I was the one that would go to the store of the OG'z to get whatever.

I was the kid that never had any presents under the Christmas tree

and if I did it wasn't from my parents, it was donated

to Moms from the San Francisco Fire Department to give to me.

I was the kid that was starving with nothing in the refrigerator

wishing I had something to eat.

I was the quick go getter money flipper, money dipper, child hitter, call me Mr.

I was the first that started and no one put me out.

I was the one who who-who'd like an owl because I was confused.

I was a group home failure.

I am the gifted, talented young man who came from the land of wealth, Africa.

I am a scholar who's going to college to seek more knowledge so that I can stay solid.

I am in love with myself, a mysterious woman, my Mom and God.

I am a love poem that is unlimited.

I am a magnetic force who attracts the most information I can.

I am a man who can withstand any competition that comes my way.

I am the ocean that moves at any uncoordinated, unrecovered motion.

I am the dry, crackled, itching, scratching, burning, heated skin that has no lotion.

I am the Alien flying in the UFO who no one believed exists that's gone in a twist.

I am a God in my own fashion that leaves people laughing without asking.

I am *I am* *I am*

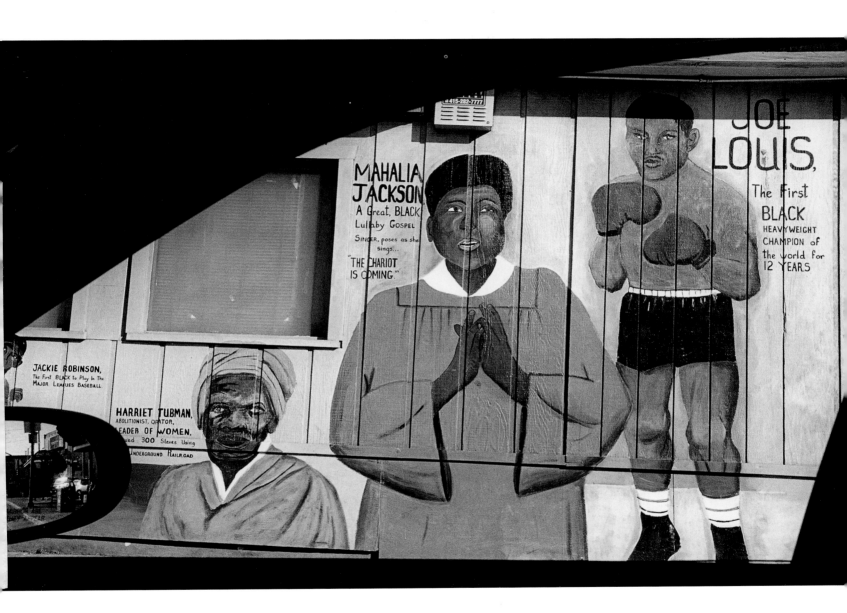

*Bayview
Opera House
community-
center mural*

God gave me a gift to come up. I understand the demons that are killing us off, and I've got them in check right now.

LANCE

Lance in San Francisco's Haight-Ashbury district

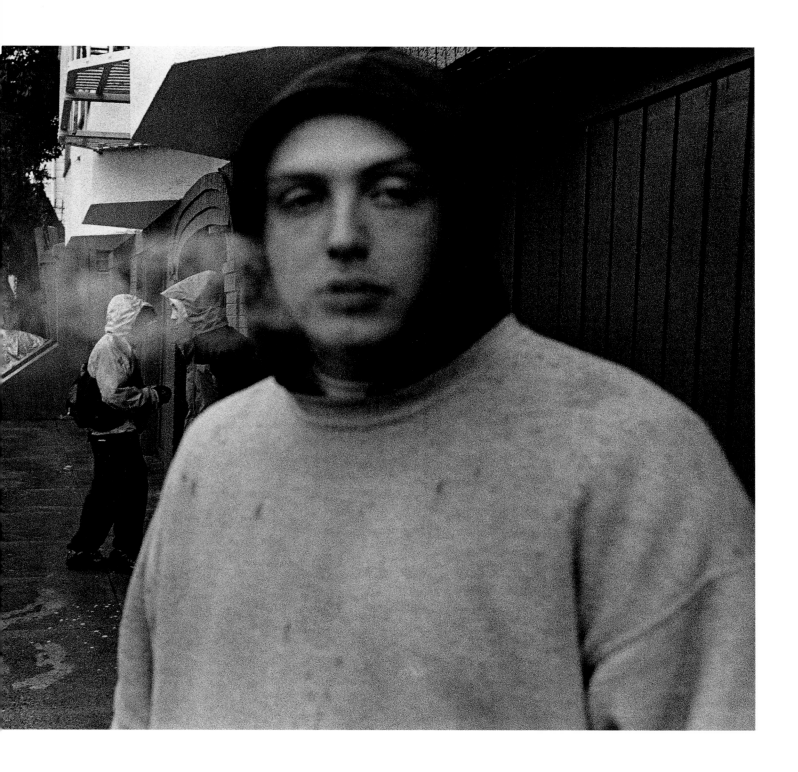

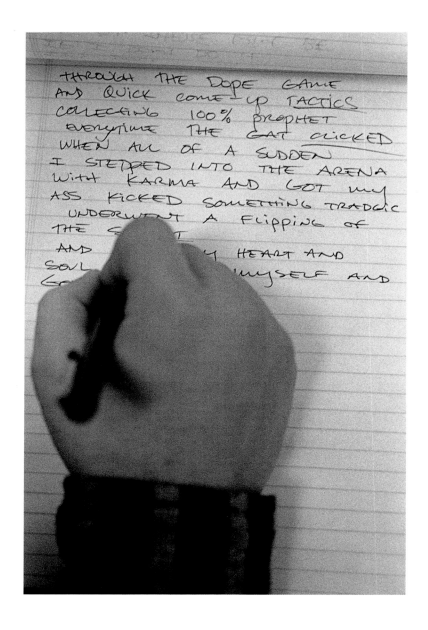

Lance
writing poetry
for The Beat
Within, *San*
Francisco

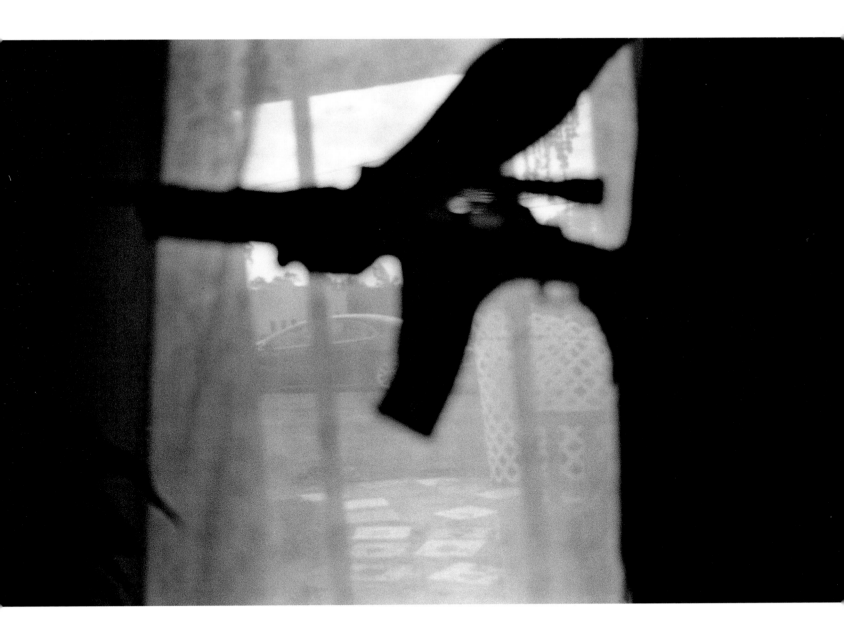

Lance
at home,
San
Andreas

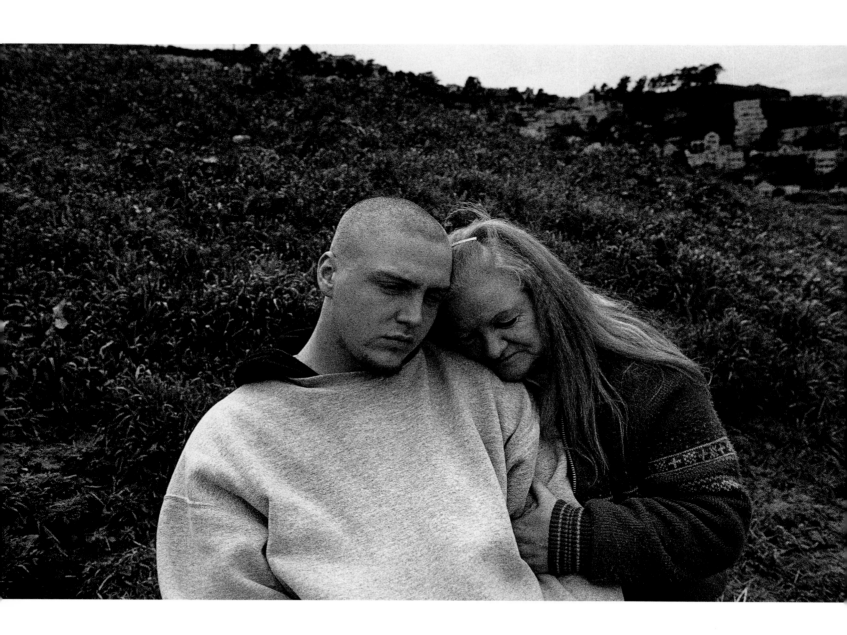

Lance
and his
mother,
Twin Peaks

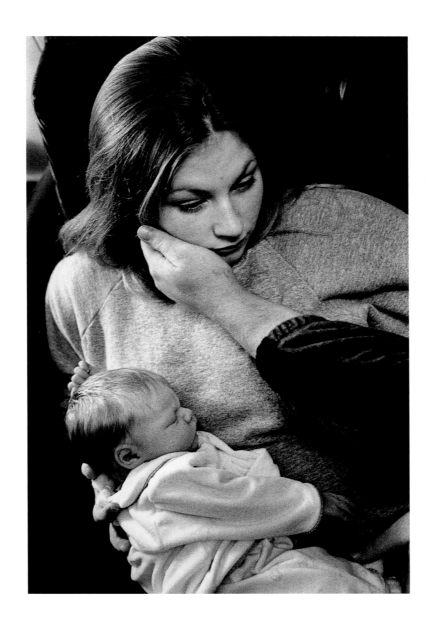

Sarah,
Lance, and
their baby
daughter,
San Andreas

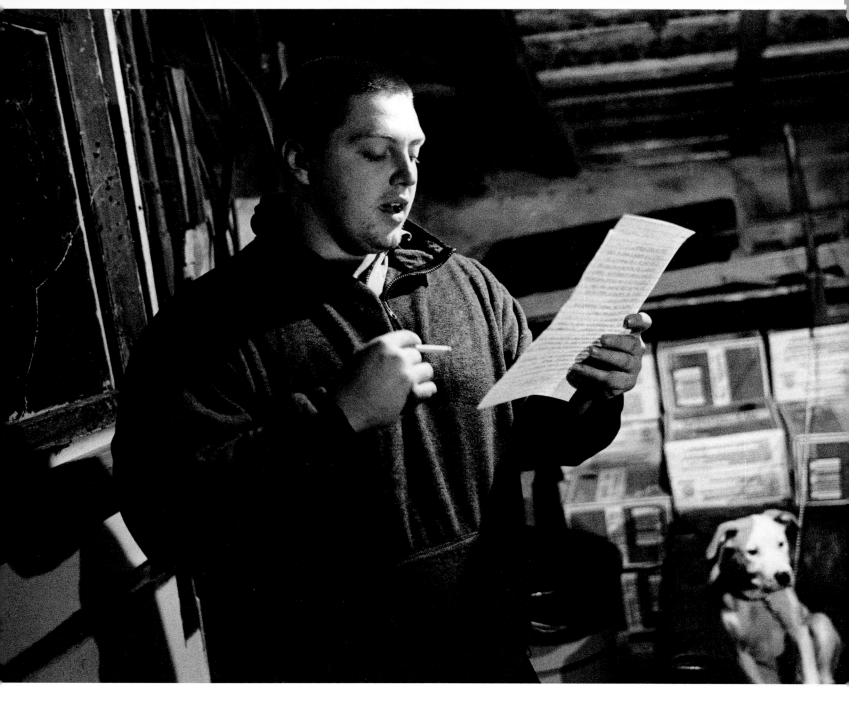

*Lance
reciting
one of
his poems,
San Andreas*

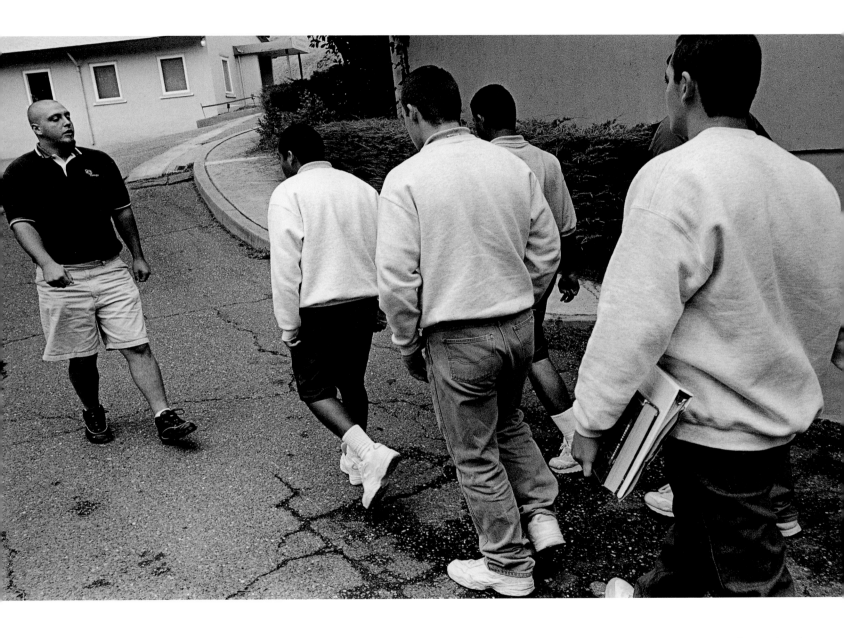

Lance at work at Rites of Passage, a juvenile facility, San Andreas

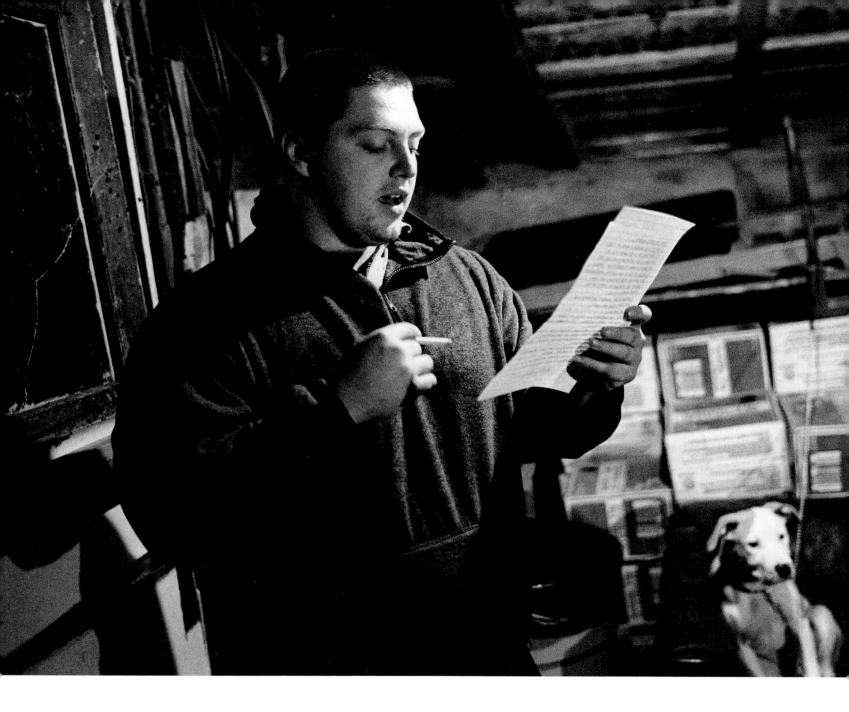

Lance
reciting
one of
his poems,
San Andreas

I left San Francisco because I was becoming suffocated by the ignorance there. I was tired of the tough-guy shit, the materialistic worth that is placed on us down there. Up here in San Andreas, I have elbow room, room to breathe, to let my guard down and rest my brain. I wanted to surround myself with things that reflect the essence of who I am—like nature and beauty.

I wanted my mother to take care of me. I went a long time without getting a hug or an embrace, or hearing that everything is going to be okay. Even if you don't believe it, it makes the pain of this messed-up world go away for the moment.

LANCE

Michael,
under
house
arrest,
San Jose

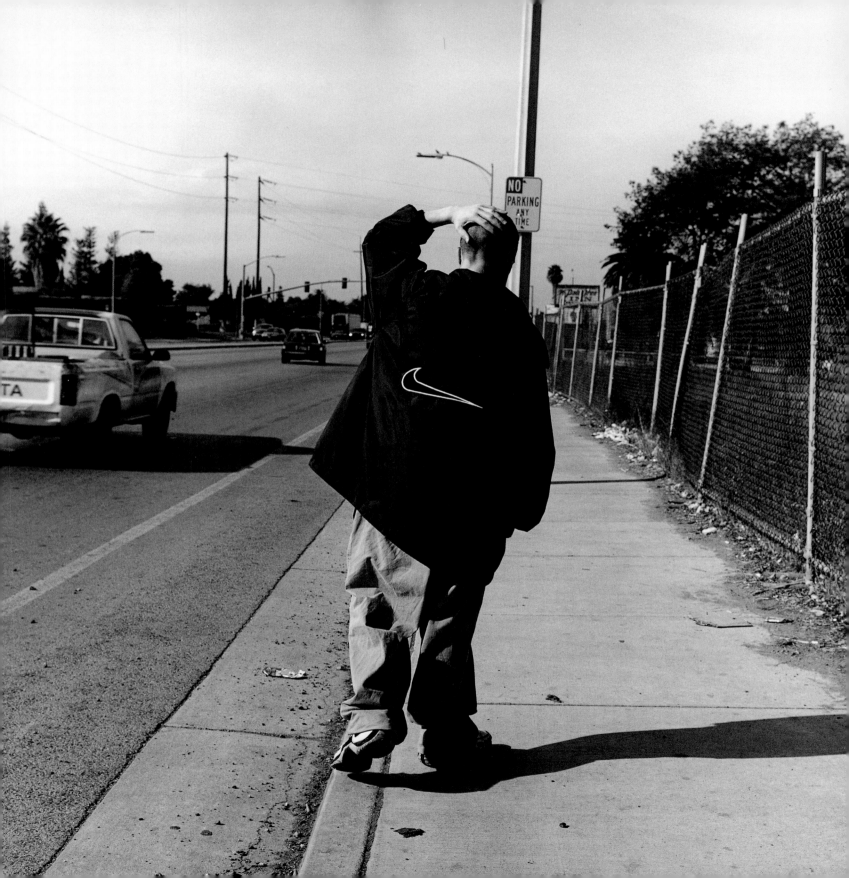

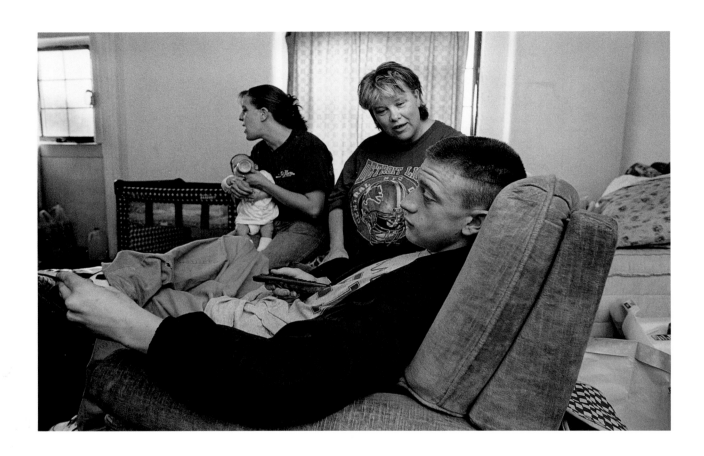

*Michael
at home
with his
family,
San Jose*

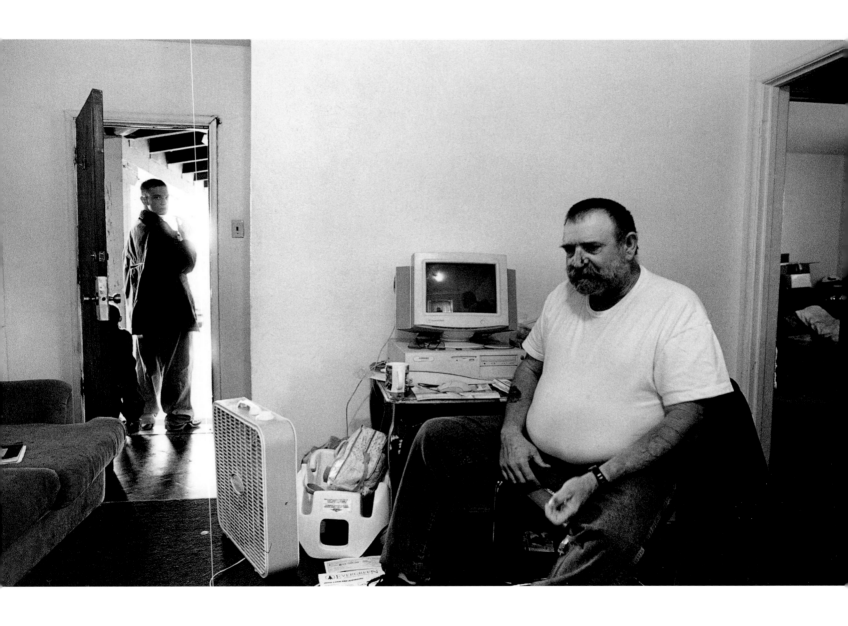

*Michael
and his
father,
San Jose*

It's media coverage that's soaring....Failure to put the real facts about kids' behavior into context has generated an unnecessary atmosphere of fear.

VINCENT SCHIRALDI
Director of the Justice Policy Institute

Michael with his father and nephew, San Jose

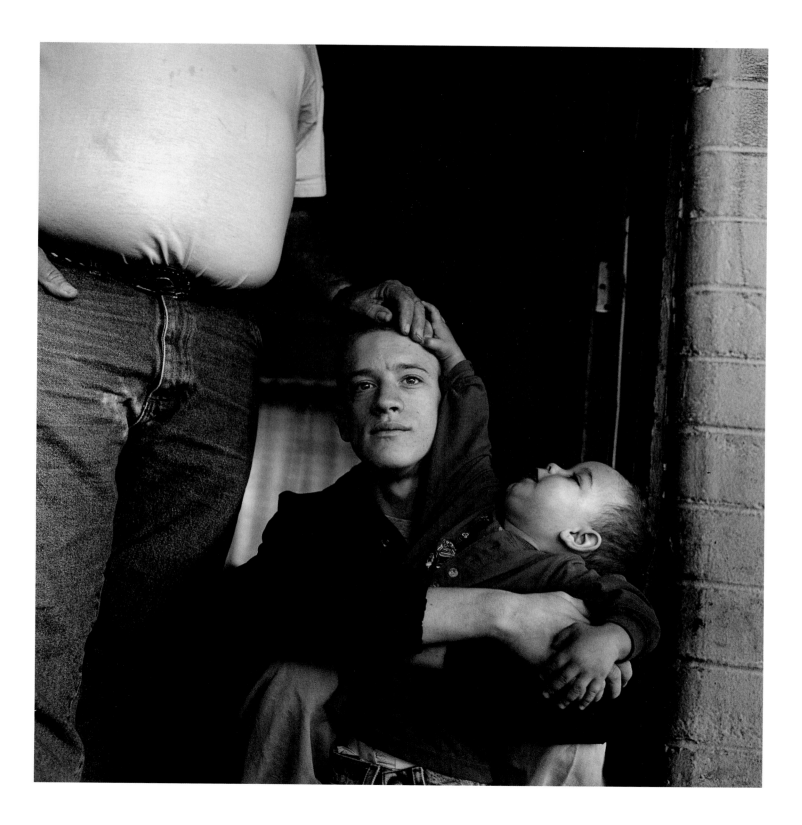

Lunchtime
lineup
and
roll call

INCARCERATION FROM A PARENT'S VIEW
PATRICIA BON AYALA

One of the darkest times of my life was when the San Francisco Police came to my home and put handcuffs on my then-sixteen-year-old son, Lance. The feelings of helplessness, frustration, and anger, were just a few of the emotions I felt at the time. I'm sure all parents who have had their child arrested feel the same. My son was the victim of circumstance more than anything. Being raised in the inner city, without a father, in a low-class neighborhood had a lot to do with it. Boys who have no father or role-models in their lives often turn to older boys or men as mentors, and unfortunately, sometimes they are the wrong ones. Peer pressure is very hard to ignore, especially when your home life isn't that good. We all went through it. But I think the buck starts with the parents. In my case, I had a problem with discipline. If I had practiced tough love, things might have been different! Although I did try to teach my son morals and right from wrong, I was so overwhelmed by my own problems that I couldn't see what was happening to my son.

My heart goes out to teenagers these days. They have so much to deal with. Drugs, AIDS, gangs. It's no wonder so many kids are in trouble. I think the best thing parents can do is hug their child, tell them you love them, and try to instill good values in them. It used to break my heart when I visited my son at the YGC [Youth Guidance Center] in San Francisco. I would cry when I saw those young kids in handcuffs. I wanted to go to each one and give them a big hug!

All I want to say to parents is: Listen to your teenager. Let them know they are loved. Take interest in their activities. Most of all, give them spiritual guidance. Give them positive things to do. If they have good role models, whether it be parents, grandparents, or a mentor, chances are they will not get into trouble. With a world so full of negative input, we need to give out positive input as much as possible to our kids. With so much violence in the media, we have to work even harder at instilling good morals in our teenagers.

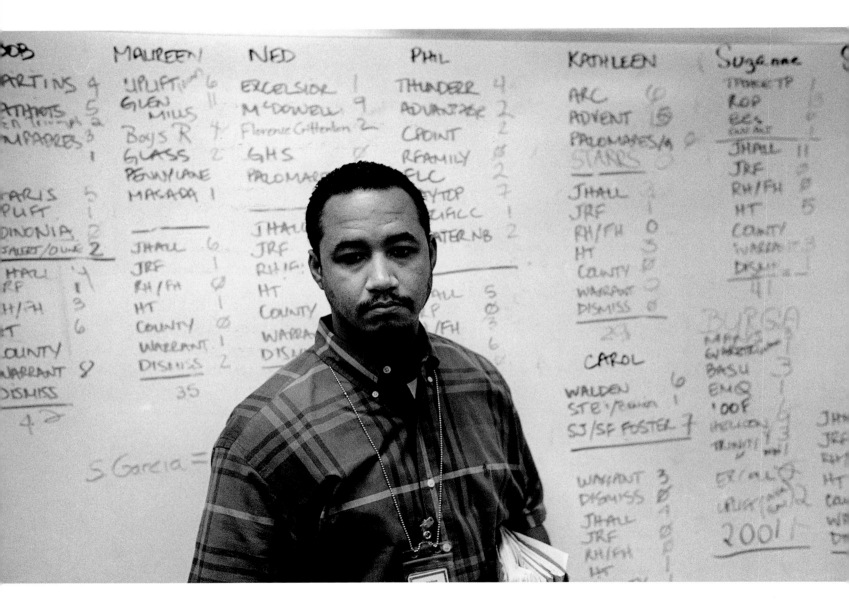

Brent
Cooper

I have seventy cases, and fifteen pending. Juvenile probation has a lot more casework involved. I have to answer to the families, schools, court, mental-health workers....The minimum cases I see once quarterly, in or out of my office—at schools, at the home; the maximum cases I see once a month, face-to-face.

Collaboration is the key for the kids; most of the time it's the families that need help. We can never start too early with family intervention. It takes a lot of money and time to fix someone, and less money to lock them up.

I would like to be able to spend more time with each kid, but I have to keep up with all the paperwork that's necessary in the system. My most important responsibility is preparing the reports for the court. Supervision is secondary.

I can't help all these kids; there is only a handful that I can save. I don't have the time to make a rapport with all the parents of the kids on my caseload, but those parents that call me more about their kid's progress are the ones I tend to pay more attention to. I do try and work with the kids that have that family support....

The frustration is that you have too little time and too many problems to solve.

BRENT COOPER
Deputy Probation Officer
Santa Clara County Probation Department

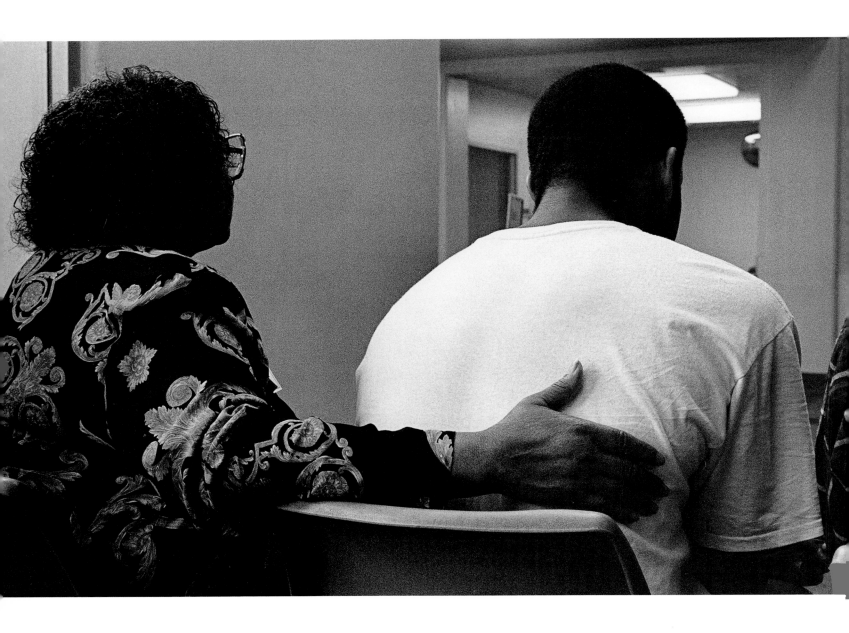

*A boy
and his
grandmother
await
his trial*

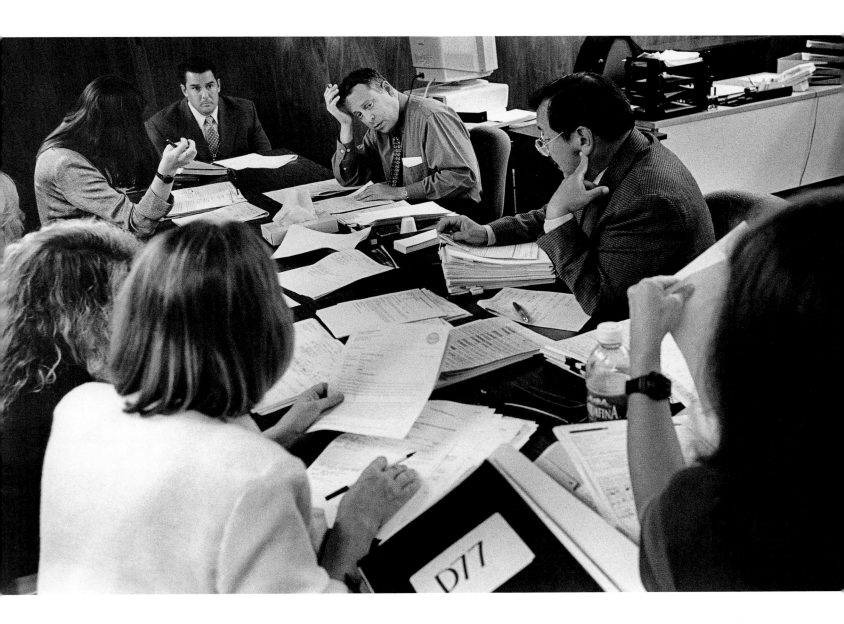

Judge Hyman organizes the court calendar with the court clerk, district attorneys, social workers, and public defenders

I came up from El Salvador when I was nine. It took us three days to cross the border—
I remember crawling through a tunnel with my sister at the border. My mother had come
up before us, and got a job as a dishwasher and a room with a kitchen in the Mission.

I learned English when I was at the Ranch [a juvenile facility in La Honda]. I also got
my GED there.

They gave me sixteen months in 1997–98 for assault.

CARLOS

*Carlos
on the
street,
San
Francisco*

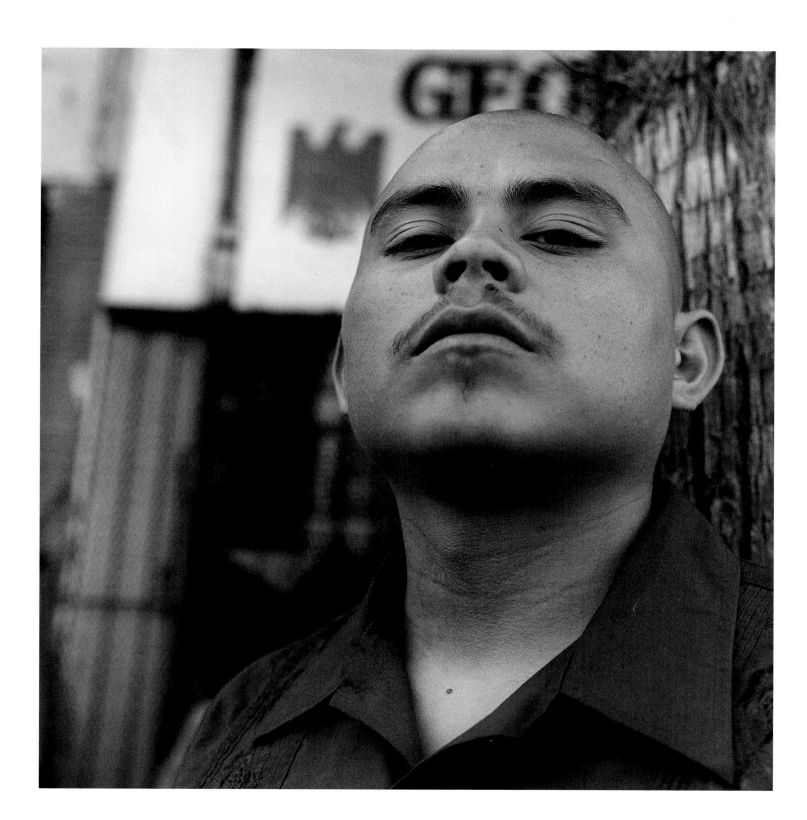

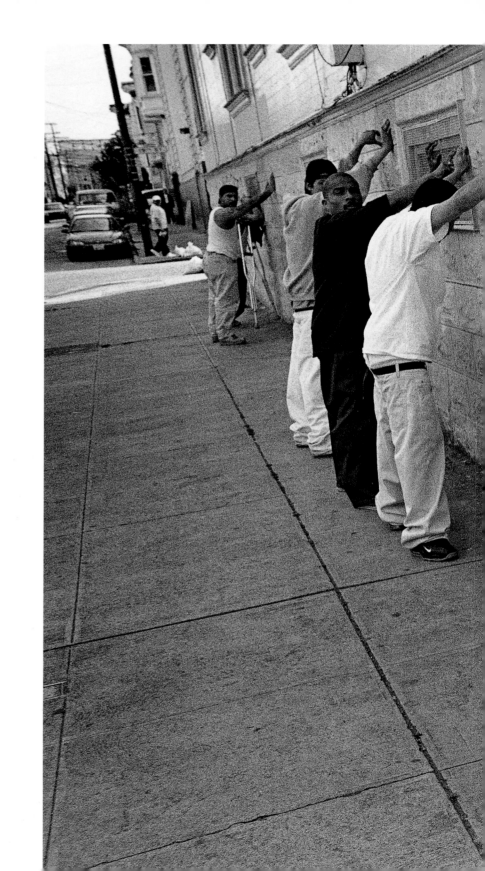

*Lineup on
a street
in San
Francisco's
Mission
district*

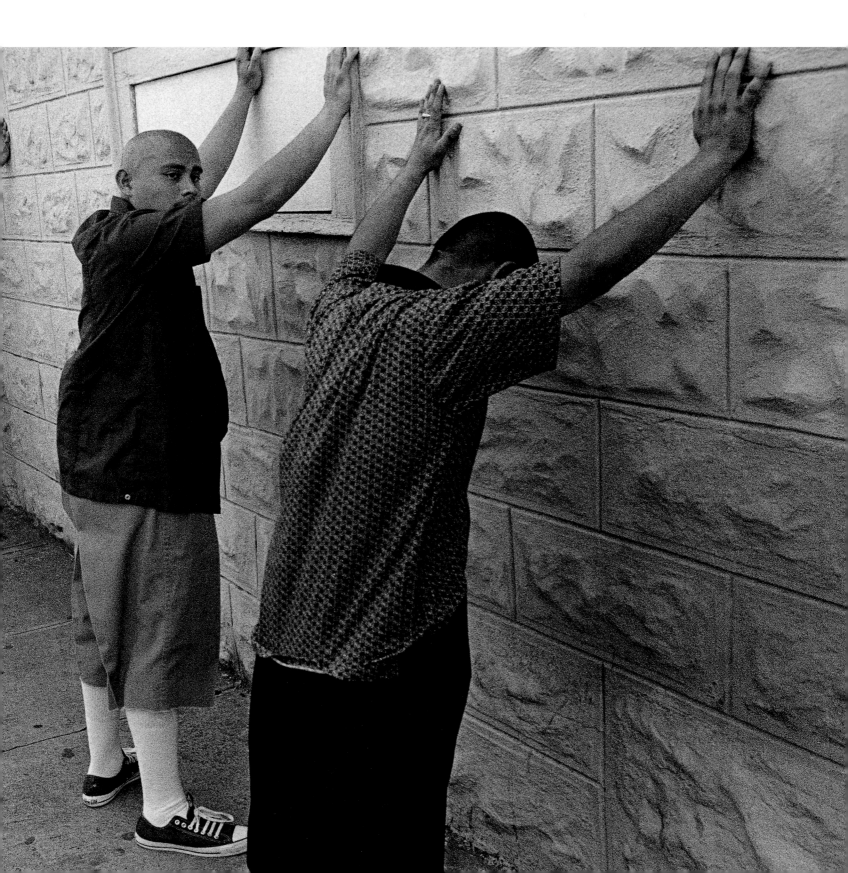

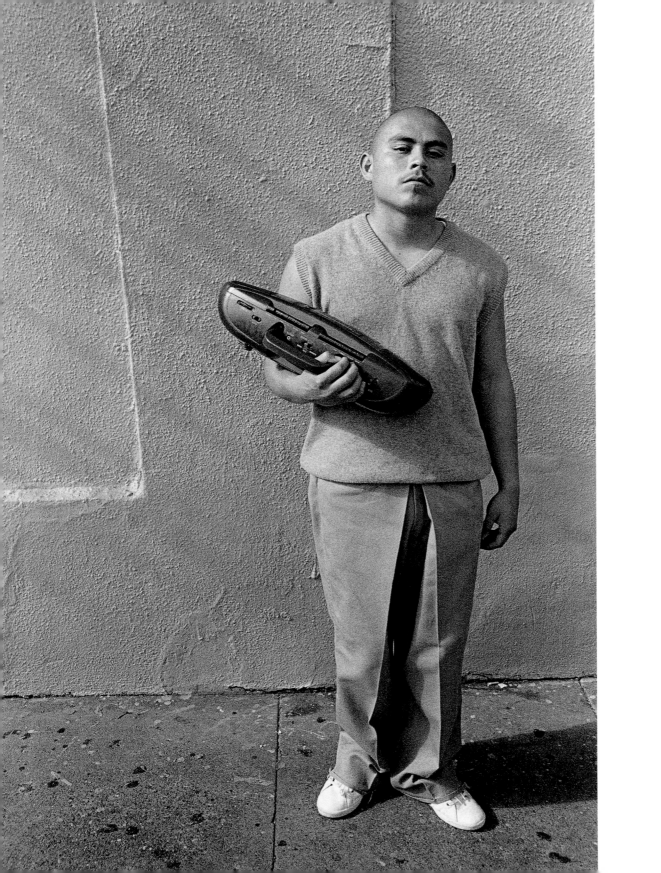

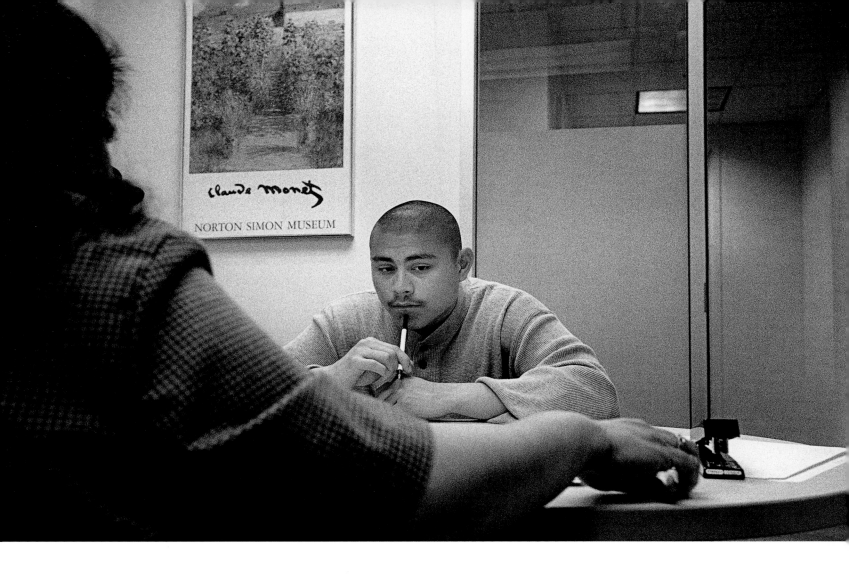

ABOVE AND
OPPOSITE:
*Carlos at
Heald
College
School of
Business and
Technology,
San Francisco*

Carlos has decided to apply to college, so he asks Cliff Parker, from the Pacific News Service, to accompany him. Carlos seems excited but nervous. They walk in and sit down with the school's admissions counselor, Doris Livingston. Later in the week, Carlos does not go back to Heald College for his scheduled interview. He is overwhelmed by all the paperwork needed to apply for financial-aid loans.

I assumed he wasn't interested, so we disposed of his application when he didn't appear for his scheduled appointment a while back. Do you know how many people I see a day who come in with all kinds of stories?

I guess miracles can happen.

DORIS LIVINGSTON, Admissions Counselor
Heald College School of Business and Technology in San Francisco

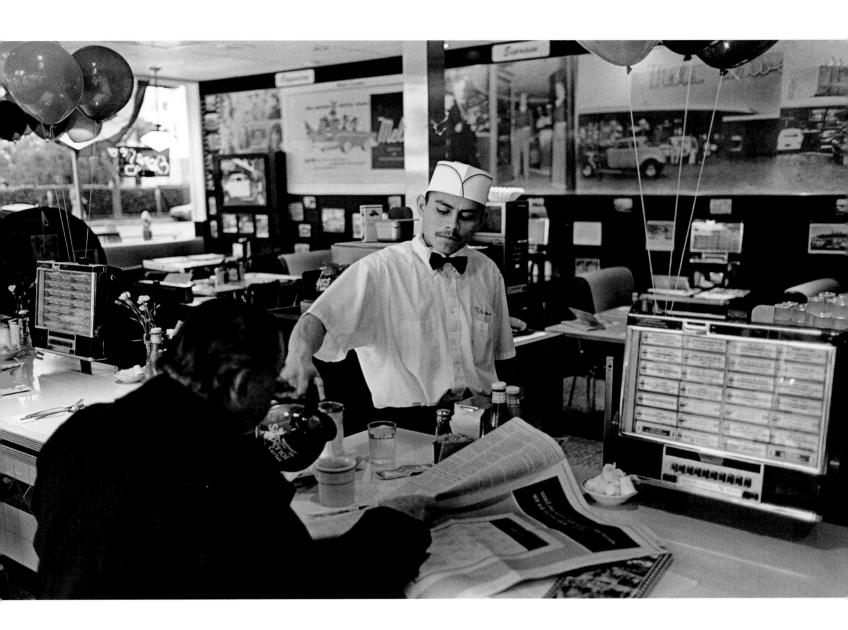

Carlos
at work
at Mel's
Drive-In

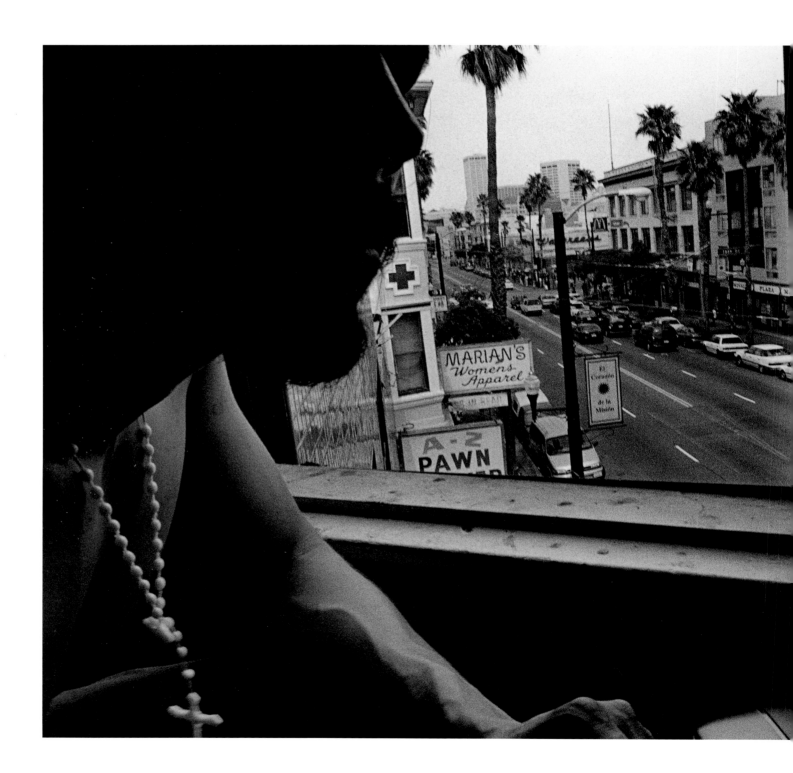

Gregorio
looking
out of his
hotel room
window in
San Francisco

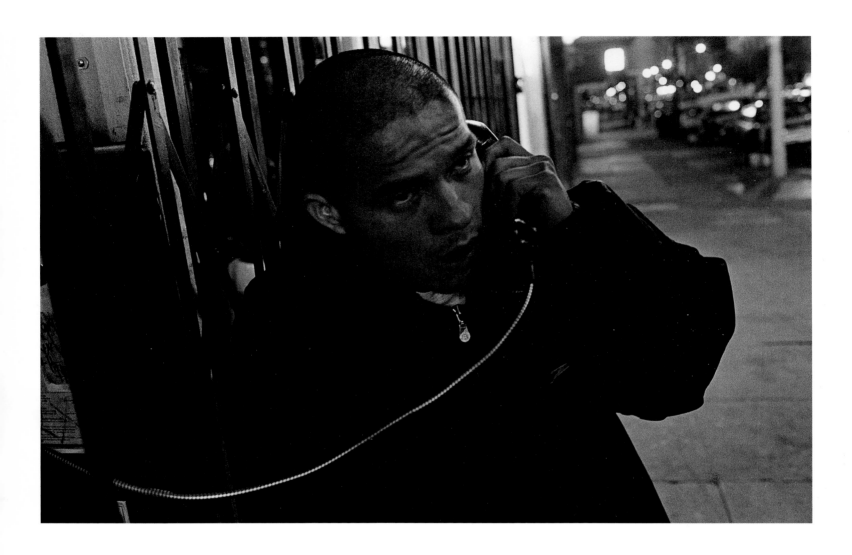

ABOVE
AND OPPOSITE:
Gregorio
spends a day
trying to track
down his
girlfriend,
Miriam

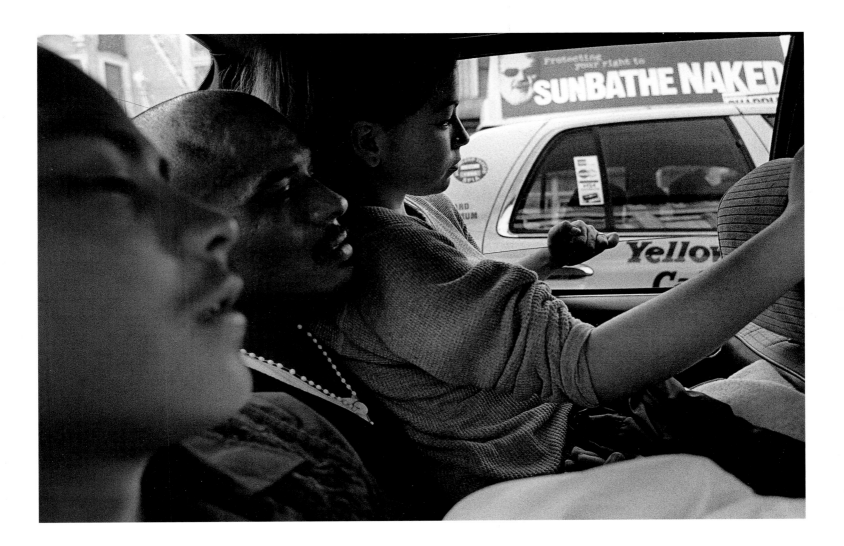

Minorities are 26 percent of the kids who are arrested, 46 percent of the juveniles in correctional facilities, and more than half of them get transferred to adult criminal court. This isn't always because black and brown kids do worse crimes than white ones. Studies demonstrate that African American youth receive harsher treatment and are more likely to be sent to a lockup than white juveniles for the same offense.

JOE DAVIDSON
"Underlying Legislation in the Juvenile Crime Bill," NPR's Morning Edition, May 18, 1999

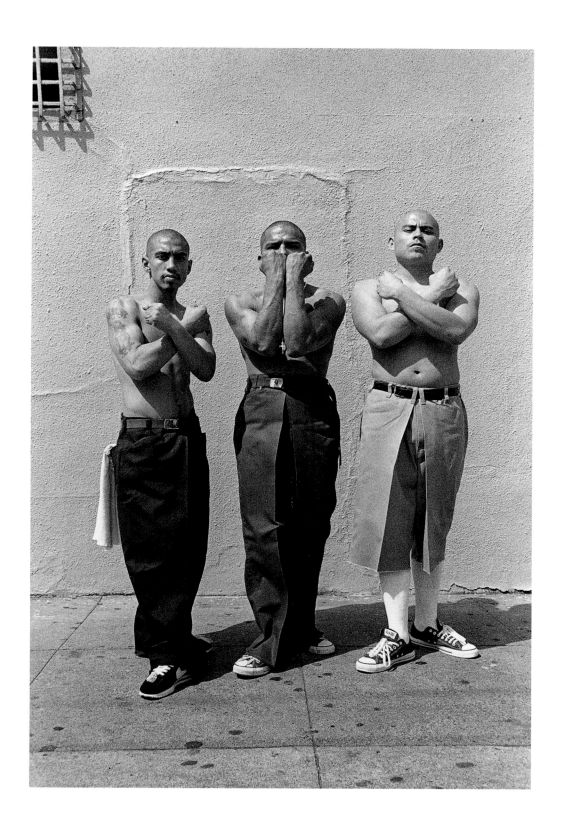

*19th Street
homeboys
in San
Francisco's
Mission
district*

I have a life here in San Francisco. I don't want to go back to Acapulco.
I almost died in 1995 when I was crossing the border. I was walking day and
night for seven days. I had no water or food—I had to drink the water from
the ground, and eating cactus gave me stomachaches.

I came to my aunt's house in Chula Vista and stayed with her for a couple
of months while I worked in the fields picking strawberries for fifteen dollars
a day, from 7 A.M. to 6 P.M., seven days a week. I later came to San Francisco
where I found the 19th Street gang. They took me in as family.

I have not seen my mother in four years. She wants me to stay with her
down there, but there's nothing for me there but poverty. My father works
in a restaurant, and he never gave her any money for us.

My favorite song is "Papa Was a Rolling Stone" by the Temptations,
because it reminds me of my father.

GREGORIO

I don't want that to happen to me. When my father and mother split up I was
bounced around to my mother's family. Our baby is due in December. My
dream is to have a family, a home, and children.

MIRIAM (Gregorio's girlfriend, pregnant with his baby)

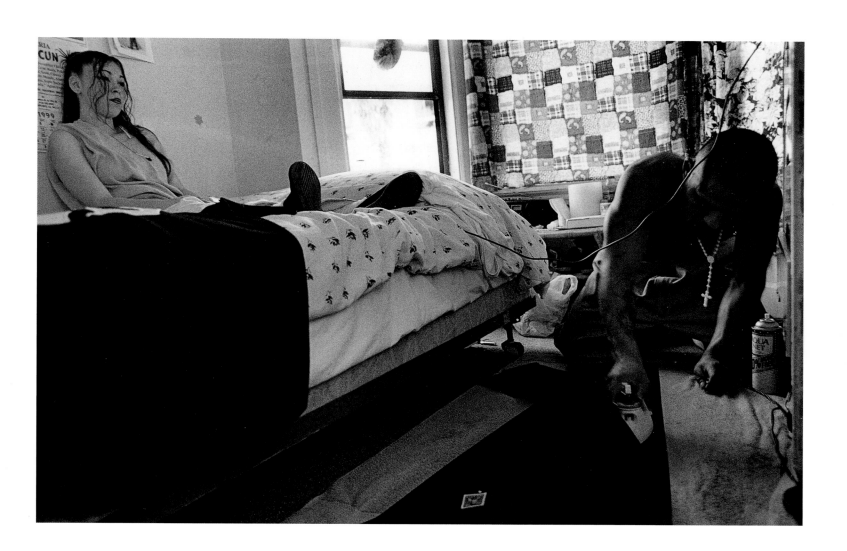

Gregorio
and
Miriam
in their
hotel room

I was born in San Francisco—don't remember too much about when I was little. We never stayed in one place too long. We lived in Kansas, Arizona, Texas, Nevada, and California.

RASHEEDAH

Rasheedah and her mother, San Francisco

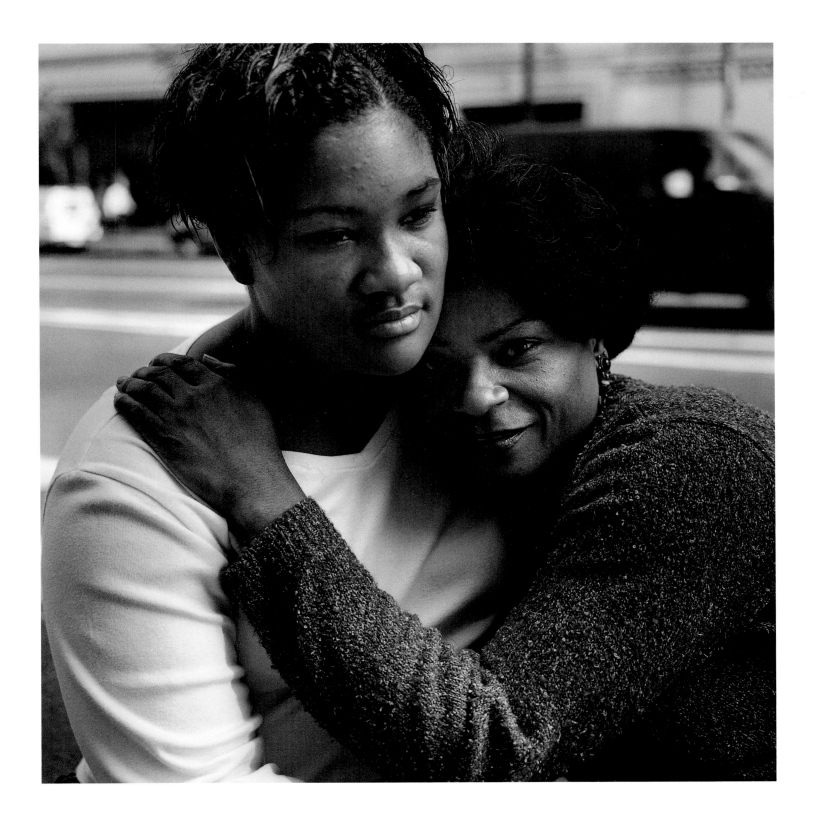

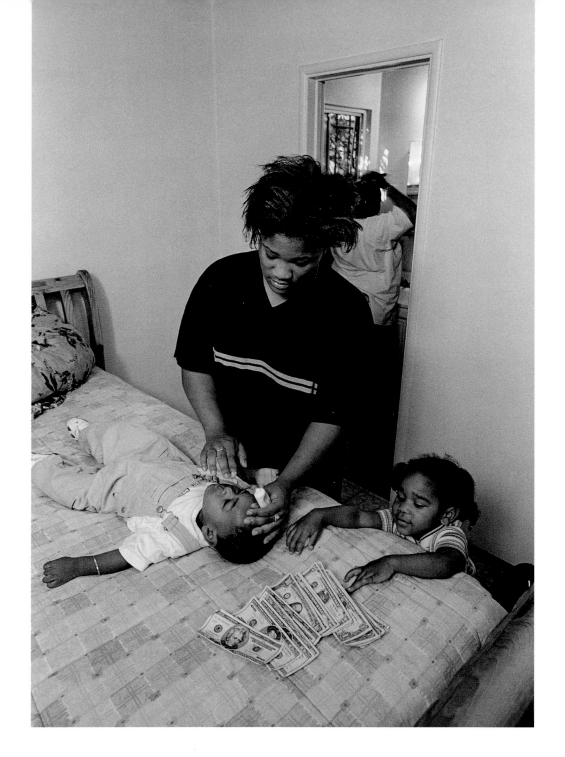

*Rasheedah
getting her
kids ready
for school,
Oakland*

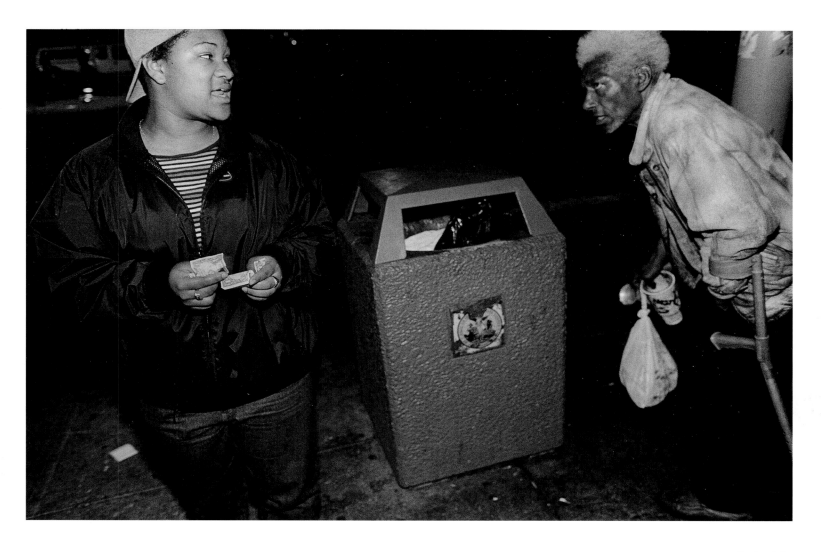

Rasheedah in San Francisco's Tenderloin district

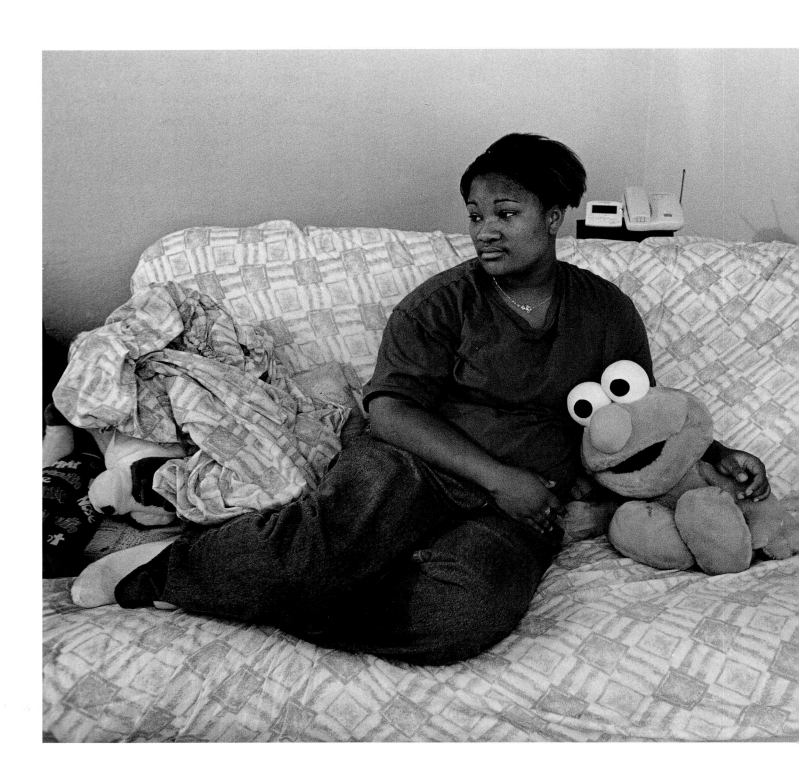

I tried to stay away from the negativity, but it was hard. Reading, writing, and exercising got me through living in my cell. Even though I was four months pregnant at the time, it didn't stop me from expanding my mind to get away from the negativity. I always said: "My body is locked up, but my mind is always going to be free."

When someone gets locked up, they often start reading and writing—then, when they get released, they forget about the things they did to occupy their time. People say they aren't going to do the same things, and that they won't come back, but they end up doing it anyhow.

I can't predict the future, and I am not going to contradict myself, but I hope never to come back to this life in my cell. Not being able to walk around freely is a feeling that I never want to have again. Negativity is powerful. The cell and this system will suck you and all the power that you have and destroy it. A word to the wise: Stay away from jail, because that's where the strongest negativity lurks.

RASHEEDAH

*Rasheedah
at home,
Oakland*

From the window of a house, Richmond

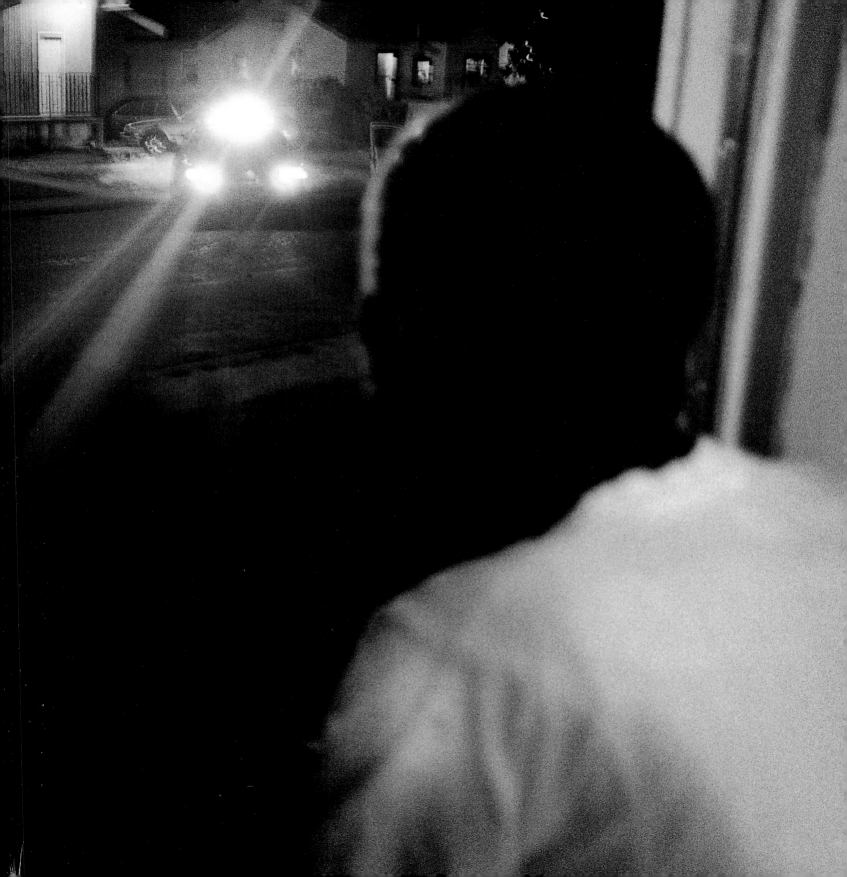

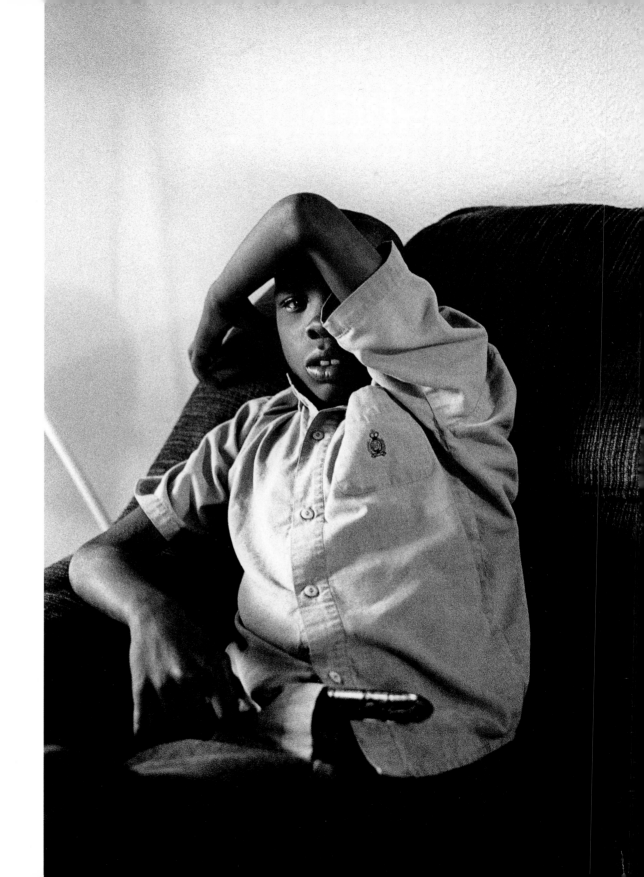

*Boy in
Richmond*

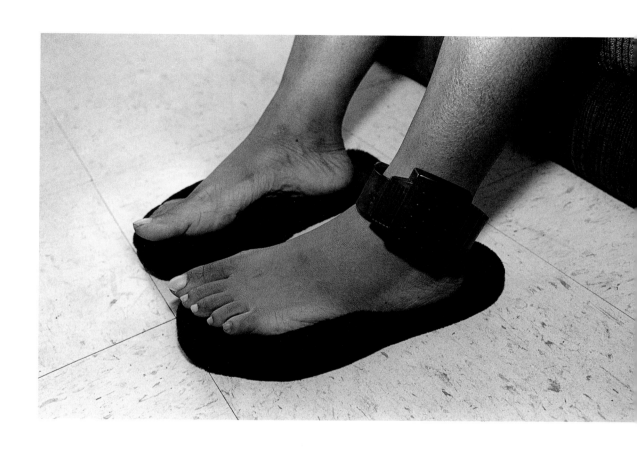

House
arrest
bracelet,
Richmond

The U.S. is turning back the clock. The focus is changing from rehabilitation to punishment.

JOE BAKER
Amnesty International

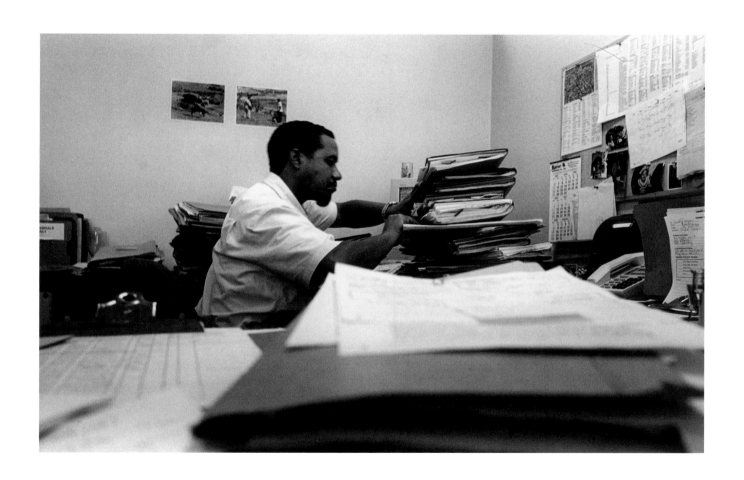

Probation
officer
Brent Cooper
prepares
for court

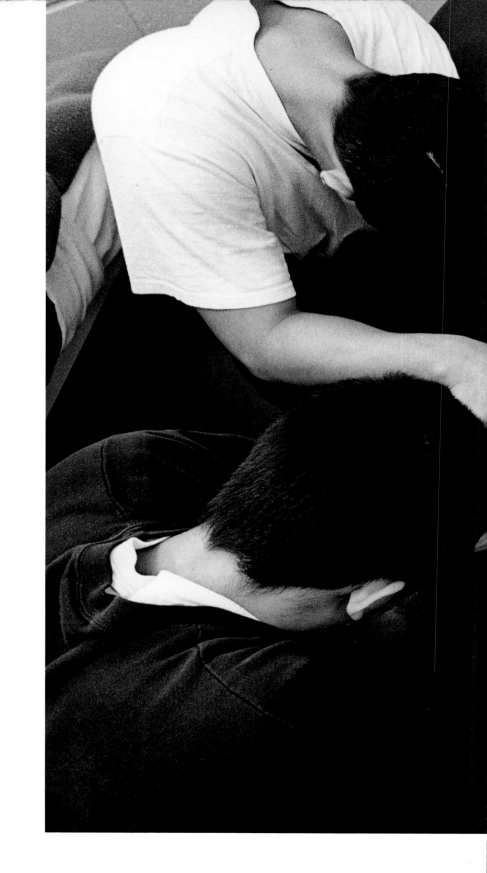

*A group
of youths
praying—
because of
Proposition 21
these kids
will be
tried as
adults*

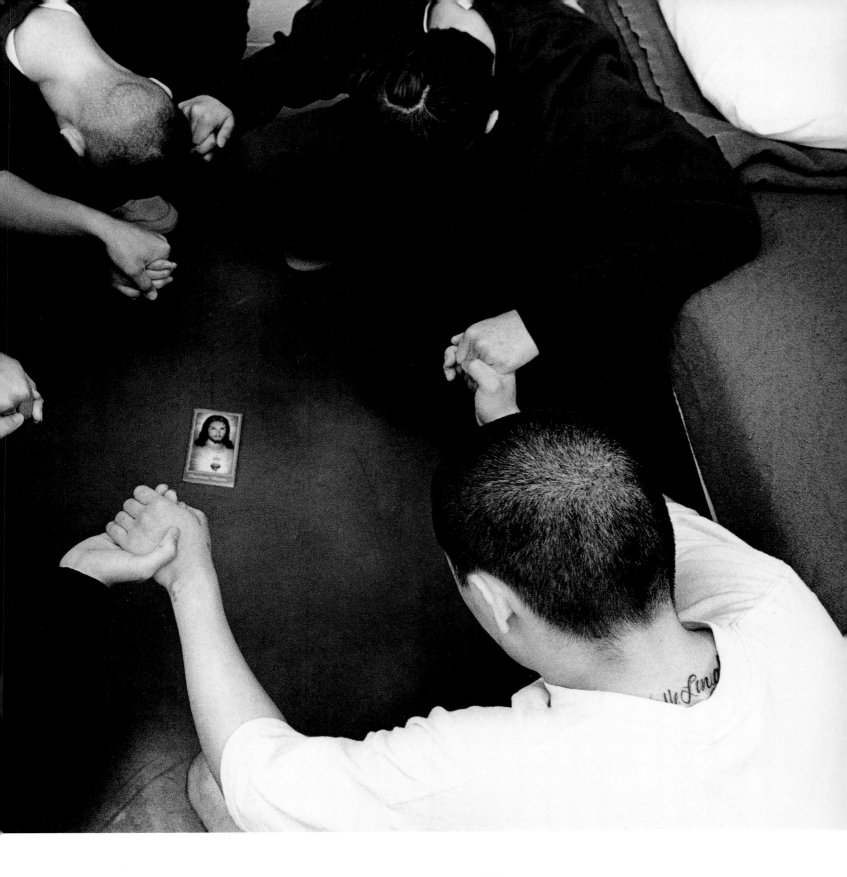

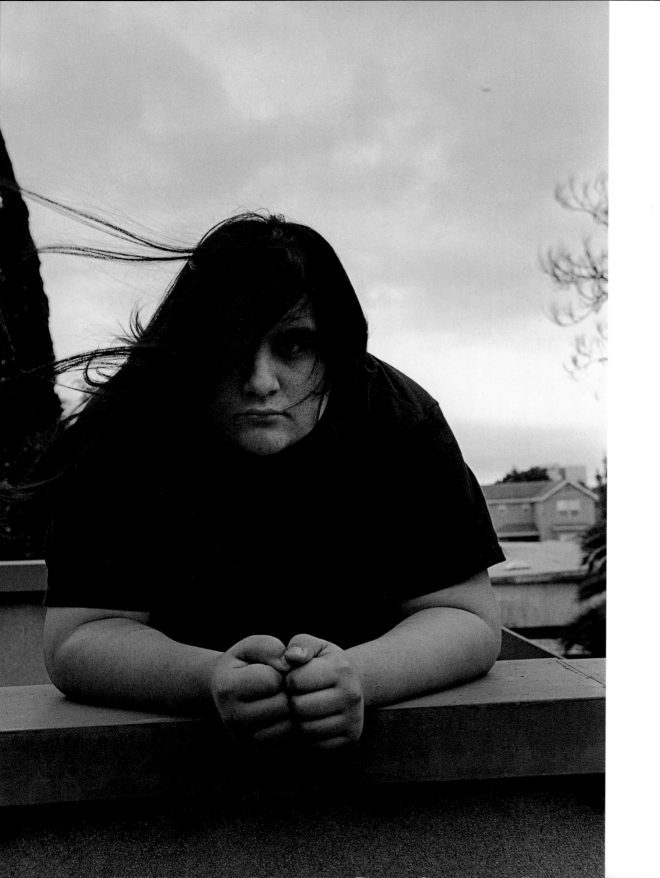

*Upon his
release after
nineteen
months in
Santa Clara
County
Juvenile Hall,
Louie was
sent to a
group home*

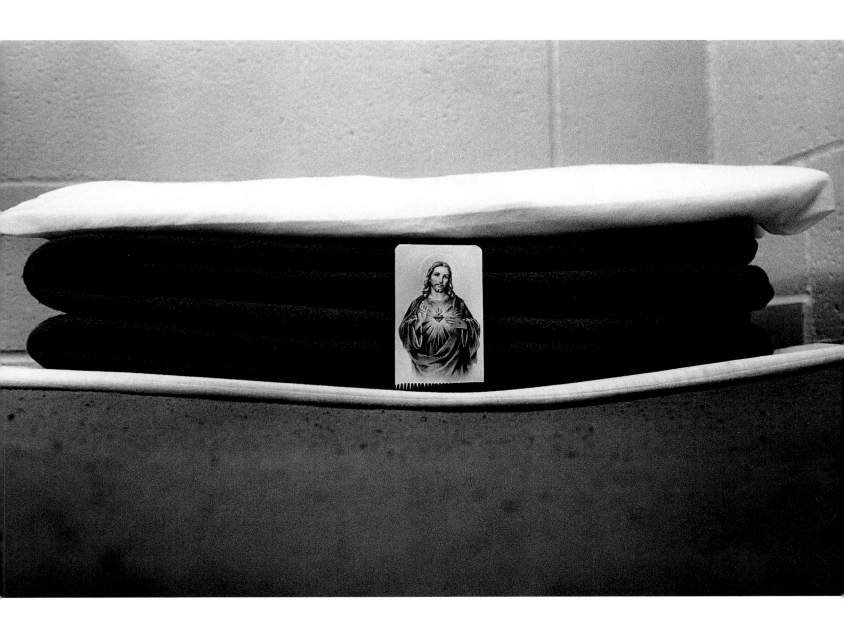

Blinky's
bed

ACKNOWLEDGEMENTS

There are many people who have helped this project to happen, and I am deeply grateful to all of them. First and foremost, I'd like to thank Sandy Close, the brilliant woman behind the Pacific News Service (including *The Beat Within* and *YO!* magazine), New California Media, and innumerable other nonprofit publishing ventures in California. Sandy's unending compassion and commitment are truly an inspiration, and this project could never have happened without her.

David Inocencio developed *The Beat Within*, and it is his unflagging spirit that keeps it going. Cliff Parker and the rest of *The Beat Within* team also deserves a special thanks for the extraordinary work they have done for so many California youths.

Thank you to Nell Bernstein, whose essay in this book reflects her long-term dedication to helping young people, and brings light to some of their stories.

The world lost a talented writer in RiChard Magee, who passed away during the course of this project. RiChard, we miss you, and thank you for your work.

I'd like to express my profound appreciation to the Open Society Institute's Criminal Justice Initiative (in particular Miriam Porter, Helena Huang, and Kate Black) for their support of this project.

I am grateful to Joe Davidson, a writer of remarkable integrity and focus, for his friendship and support. My thanks also go to Vincent Schiraldi and the Justice Policy Institute as well as to Kim Nelson of the WritersCorps of San Francisco.

This project received financial support from the Swedish Arts Council's Konstnärsnämnden, and my work was exhibited at the Stockholms Stadsmuseum. My thanks go to both institutions for their invaluable aid, and also to the Swedish journal *Dagens Nyheter* for helping to bring international attention to my work.

Christa Gannon of the Santa Clara County Public Defender's Office really helped to pave the way for me in San Jose—I'm very grateful to Christa and her organization, Fresh Lifelines for Youth. Thanks also to Brent Cooper of the Santa Clara County Probation Department; to the counselors and administration of the Santa Clara County Juvenile Hall, particularly Chris Parker, Mr. Sullivan, Tim Valdez, and Denise Galvaris; and to Judges Hyman and Edwards and the entire staff of the Santa Clara County Juvenile Court.

This project was largely created at juvenile facilities; without their cooperation this work would have been nearly impossible. My thanks go to Johnny Miller of the Log Cabin Ranch in La Honda, as well as to the people at the Foundry School in San Jose, and at Rites of Passage in San Andreas.

Fred Ritchin is without question the person who has most influenced me as a photographer; Fred opened the world of this medium to me, and made me understand the power it can have. He is always there for me, like a beacon keeping me on course—I can't sufficiently express my gratitude for this. Thanks also to PixelPress for presenting my "Juvenile Justice" work on the Internet (www.pixelpress.org/juvenilejustice).

Human Rights Watch provided financial assistance to this project, and also included it as part of their 2002 International Film Festival; particular thanks go to Bruni Burres of Human Rights Watch. The work from "Juvenile Justice" was also featured on PBS's *Egg: The Arts Show*.

Brian Young is a remarkable printer who has handled all of my work. The images in this book would never have looked this way without his talents—I am very grateful to him, for both his work and his friendship.

Garrett Gee has stood by me through thick and thin; his devotion and expertise have been invaluable to me. Garrett has brought me into the world of new technology, and I am very grateful to him. My thanks also to Robbie Patrick, who has been an enormous help.

Regina Monfort has provided vital support to me and my work over the years. Thank you, Regina, for your friendship.

Yuko Uchikawa is an extraordinary designer, who goes beyond mere graphics and look, and brings to any project a profound understanding of the work as a whole. It has been my great pleasure to work with Yuko again. Thanks also to Diana C. Stoll, who is an extraordinary editor, and who worked closely with me on the book's texts.

I owe a major thanks to the powerHouse family: Daniel Power and his wonderful staff, particularly Craig Cohen, Sara Rosen, Kristian Orozco, Meg Handler, and Daniel Buckley. Without the support of powerHouse, this book would not exist.

Last, I am deeply grateful to all the young people and families with whom I've had the honor to work during the course of this project. Thank you to all, for your courage and for your fortitude.

—JR

The publisher would like to express its gratitude to the Open Society Institute for its generous support of this publication. We would like to extend a special thanks to Helena Huang of OSI for her vigorous endorsement of this work.

JOSEPH RODRÍGUEZ's photographs have appeared in such publications as *The New York Times Magazine*, *Esquire*, *National Geographic*, *Newsweek,* and *Stern*. He has received awards and grants from numerous foundations, including the Open Society Institute, the National Endowment for the Arts, the Rockefeller Foundation, and the Mother Jones International Fund for Documentary Photography, and has been awarded Pictures of the Year by the National Press Photographers' Association in 1990, 1992, 1996, and 2002. Previous publications include: *Spanish Harlem* (National Museum of American Art, Smithsonian Institution/D.A.P., 1995); and *East Side Stories: Gang Life in East L.A.* (powerHouse, 1998).

In 2001, a web site of Rodríguez's work, titled *Juvenile Justice*, was presented with the cooperation of Human Rights Watch and PixelPress (www.pixelpress.org/juvenilejustice). This project was also shown at the Human Rights Watch International Film Festival in 2002.

Rodríguez teaches courses in photography at New York University and the International Center of Photography in New York, and has lectured at universities in Europe and Mexico. He is affiliated with the Black Star agency and Pacific News Service, in the U.S., and Pressens Bild in Sweden. He lives in Brooklyn.

NELL BERNSTEIN was a longtime editor of Pacific News Service's monthly magazine *YO!* (*Youth Outlook*). In 2000 she published "A Rage To Do Better: Listening to Young People from the Foster Care System," a Pacific News Service report based on interviews with and surveys of teenagers currently and formerly in foster care and juvenile hall. Bernstein later organized and moderated a series of panels on foster care at the California State Legislature, and delivered the keynote address at the Foster Family-Based Treatment Association's annual convention in Atlanta.

Bernstein has received a Soros Justice Media Fellowship from the Open Society Institute's Criminal Justice Initiative in New York, and the PASS Award from the National Council on Crime and Delinquency. She has also been awarded a Journalism Fellowship in Child and Family Policy from the University of Maryland School of Journalism.

Bernstein's writings have appeared in numerous publications, including *Mother Jones, Legal Affairs*, *Health, Self, Redbook,* and *The Washington Post*. She lives in Berkeley, California.

JUVENILE

Published in the United States by powerHouse Books,
a division of powerHouse Cultural Entertainment, Inc.
68 Charlton Street, New York, NY 10014-4601
telephone 212 604 9074, fax 212 366 5247
e-mail: juvenile@powerHouseBooks.com
web site: www.powerHouseBooks.com

First edition, 2004

Library of Congress Cataloging-in-Publication Data:

Rodríguez, Joseph.
 Juvenile / photographs by Joseph Rodríguez ; introduction by Nell
Bernstein.-- 1st ed.
 p. cm.
ISBN 1-57687-138-X (Hardcover)
 1. Juvenile justice, Administration of--United States--Pictorial
works. I. Title.
 HV9104 .R623 2003
 364.36'0973--dc21

 2003011188

Hardcover ISBN 1-57687-138-X

Separations, printing, and binding by Sfera International, Milan

A complete catalog of powerHouse Books and
Limited Editions is available upon request;
please call, write, or step into our web site.

10 9 8 7 6 5 4 3 2 1

Printed and bound in Italy

Book design by Yuko Uchikawa

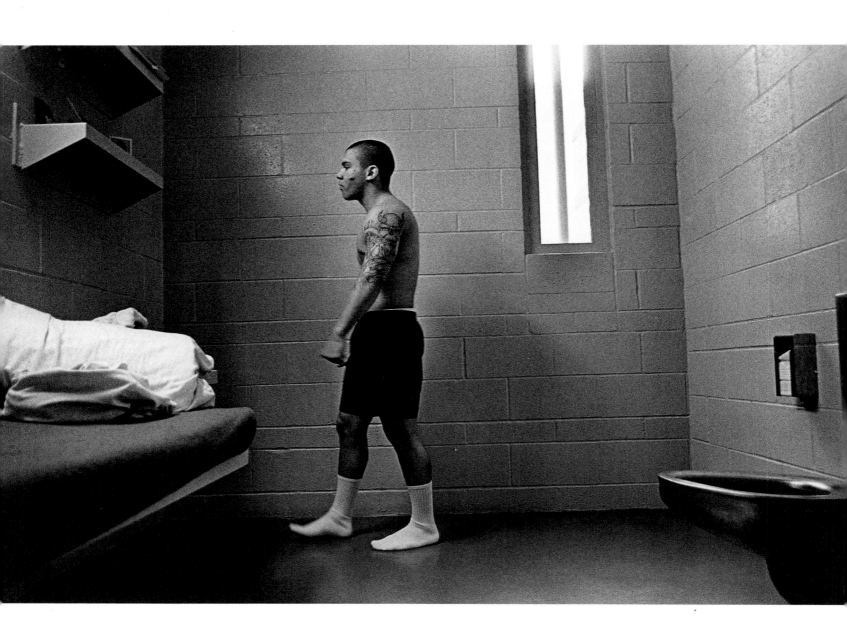